IMAGES

ARTISTS' VIEWS OF PLACES IN THE CARE OF THE NATIONAL TRUST

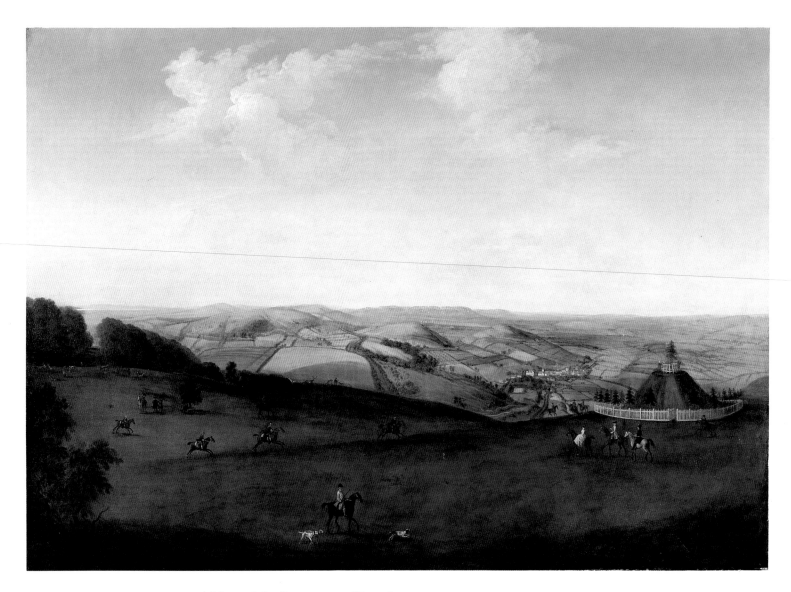

Peter Tillemans *A View of the Downs near Uppark* UPPARK, WEST SUSSEX (Fetherstonhaugh Collection)

IMAGES

ARTISTS' VIEWS OF PLACES IN THE CARE OF THE NATIONAL TRUST

OLIVER GARNETT

THE NATIONAL TRUST

IN ASSOCIATION WITH

FOR JANE AND RICHARD

First published in Great Britain in 1995 by National Trust
Enterprises Ltd, 36 Queen Anne's Gate, London SW1H 9AS
in association with Royal Mail

British Library Cataloguing in Publication Data
A catalogue record for this book is available from the British Library
ISBN 0 7078 0210 5

Designed by Peter Guy

Production by Bob Towell

Phototypeset from disc in Monotype Ehrhardt by Southern Positives and Negatives (SPAN), Lingfield, Surrey
Printed and bound in Hong Kong
Mandarin Offset Ltd

CONTENTS

INTRODUCTION

In December 1853 the fifteen-year-old Octavia Hill met the great Victorian art critic and artist John Ruskin for the first time. Ruskin was impressed by her talents as a painter and offered to take her on as a pupil. From that artistic impulse grew their friendship, and from that friendship she absorbed many of the ideas that led her to help found the National Trust in 1895.

It has become a truism that we see the landscape of Britain through the eyes of its painters. The Stour valley on the border of Suffolk and Essex is unthinkable today without Constable, the park at Petworth in West Sussex without Turner, and it was artists that first made a wider nation appreciate the beauties of the Lake District. Not surprisingly, these images have had a powerful influence on the work of the National Trust, and artists themselves have from the start played a role in shaping its decisions. When the Old Post Office in Tintagel was threatened with demolition in 1895, Catherine Johns and a group of local fellow painters organised a picture sale to raise funds for its preservation. In 1947 Eardley Knollys was the moving spirit in bringing Stanley Spencer's masterpiece, the Sandham Memorial Chapel murals, to the Trust. Knollys was the Trust's agent for southern England at the time, but his first love was painting, which he retired early to pursue. In more recent years the Trust has set up the Foundation for Art, to continue the tradition of country house patronage of the arts, but also to encourage today's artists to look at what it owns in new ways.

This book brings together some of the results of the human passion for recording our surroundings in images and words. And because most places mean less without the individuals that shaped them, it begins with PEOPLE.

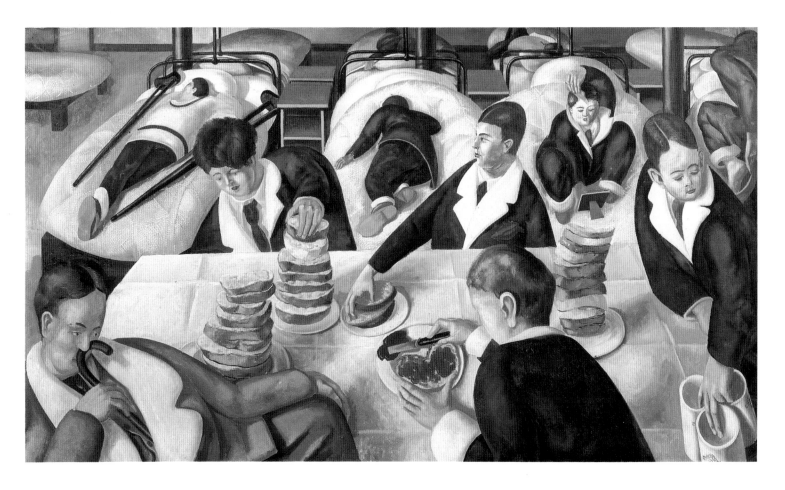

Stanley Spencer (1891–1951)

Tea in the Hospital Ward, 1932

SANDHAM MEMORIAL CHAPEL, BURGHCLERE, HAMPSHIRE

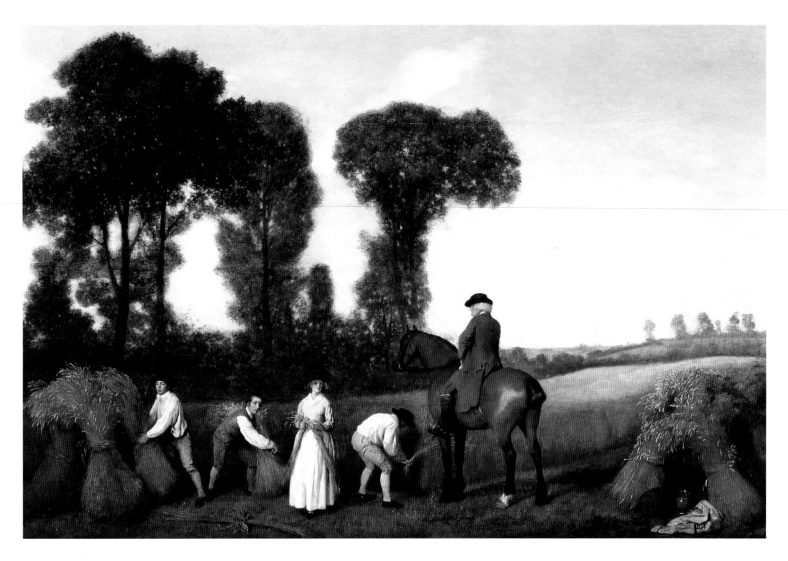

George Stubbs (1724–1806) *The Reapers*, 1783 UPTON HOUSE, WARWICKSHIRE (Bearsted Collection)

CHAPTER ONE

PEOPLE

Soon as the morning trembles o'er the sky,
And unperceived unfolds the spreading day,
Before the ripened field the reapers stand
In fair array, each by the lass he loves,
To bear the rougher part and mitigate
By nameless gentle offices her toil.
At once they stoop, and swell the lusty sheaves;
While through their cheerful band the rural talk,
The rural scandal, and the rural jest
Fly harmless, to deceive the tedious time
And steal unfelt the sultry hours away.

From James Thomson's
'Autumn', *The Seasons*, 1730

Anonymous, early eighteenth-century

John Meller's Coachboy

SERVANTS' HALL, ERDDIG, CLWYD

(Yorke Collection)

John Meller, who bought Erddig in 1716,
began the tradition of painting the house
servants with this picture. By the 1790s,
when his great-nephew Philip Yorke I
added the following doggerel, the sitter's
identity had already been forgotten:

Of the conditions of this Negre,
Our information is but me'gre,
However *here*, he was a dweller,
And blew the horn for Master Meller:
Here, too he dy'd, but when or how,
Can scarcely be remember'd now.
But that to Marchwiel he was sent,
And has good Christian interment:
Pray Heav'n may stand his present friend,
Where black, or white; distinctions, end;
For sure on this side of the grave,
They are too strong, 'twixt Lord and slave:
Here also liv'd a dingy brother,
Who play'd together with the other;
But of him, yet longer rotten,
Every particular's forgotten;
Save that like Tweedle-dum, and dee,
These but in *notes*, could e'er agree;
In all things else, as they do tell ye,
Were just like Handel, and Corelli:
O! had it been in their life's course
T' have met with Massa Wilberforce,
They wou'd in this alone, have join'd
And been together of a mind;
Have rais'd their horns, to one high tune,
And blown his Merits to the *Moon*.

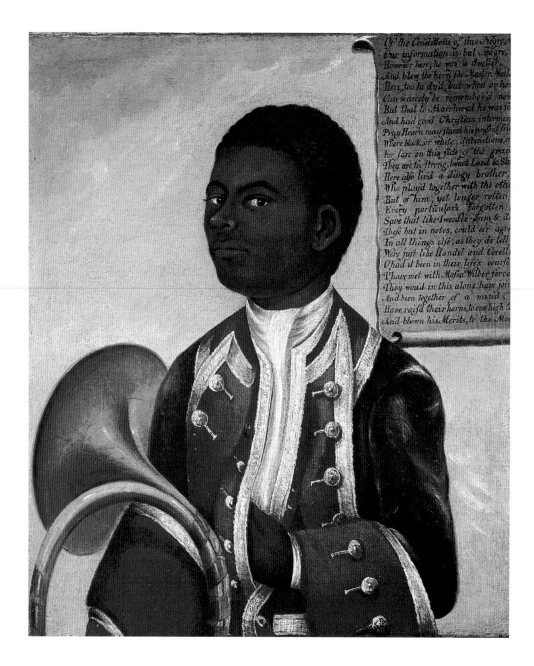

Evan Walters (1893–1951)

Cockle Woman, c.1935

GLYNN VIVIAN ART GALLERY
AND MUSEUM, SWANSEA

Women have been harvesting cockles along the north shore of the Gower peninsula in West Glamorgan since Roman times. The life of the Penclawdd cockle woman has never been an easy one, as J. Geraint Jenkins explained in 1976:

She has to leave her home, often at an unearthly hour, to travel across the inhospitable, windswept marshland to the cockle beds. Until recently, donkeys equipped with panniers were used to transport cockles, but today horse-drawn, two-wheeled carts are used. At the appointed hour a long line of carts leaves the village, the fisherwoman with her sacks, basket, riddle, scraping knife and rake, sitting on the front of each cart. Occasionally the convoy has to stop at Salthouse Point to await the ebb before venturing across the wet sand to the cockle beds. This can be a journey of considerable peril at night or in foggy weather, for a number of rapidly flowing streams, or 'pills', can prove a hazard to anyone who ventures on the beach. Each fisherwoman after arrival on the cockle beds takes her allotted section of beach and with her *scrap* scratches the surface of the sand to expose the cockles a few inches below. The cockles are then gathered together with the *cram* and placed in a sieve, which is shaken backwards and forwards and from side to side to ensure that all under-sized cockles fall through the mesh . . . Although some cockles are sold to bottling factories, it is a custom for Pen-clawdd cockle women to take cockles to market themselves.

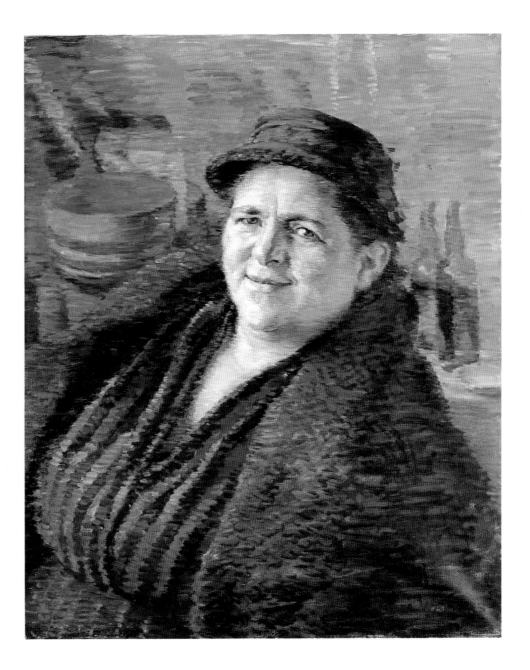

After Henry William Bunbury (1750–1811)

A Long Minuet as danced at Bath

ASSEMBLY ROOMS, BATH

But hark! now they strike the melodious string,
The vaulted roof echoes, the mansions all ring;
At the sound of the hautboy, the bass and the fiddle,
Sir Boreas Blubber steps forth in the middle,
Like a holy-hock, noble, majestic, and tall,
Sir Boreas Blubber first opens the ball:
Sir Boreas, great in the minuet known,

Since the day that for dancing his talents were shewn,
Where the science is practis'd by gentlemen grown.
For every science, in ev'ry profession,
We make the best progress at years of discretion.
How he puts on his hat, with a smile on his face,
And delivers his hand with an exquisite grace!
How genteely he offers Miss Carrot before us,
Miss Carrot Fitz-Oozer, a niece of Lord Porus!
How nimbly he paces, how active and light!
One never can judge of a man at first sight;
But as near as I guess, from the size of his calf,
He may weigh about twenty-three stone and a half.

Christopher Anstey, *The New Bath Guide*, 1766

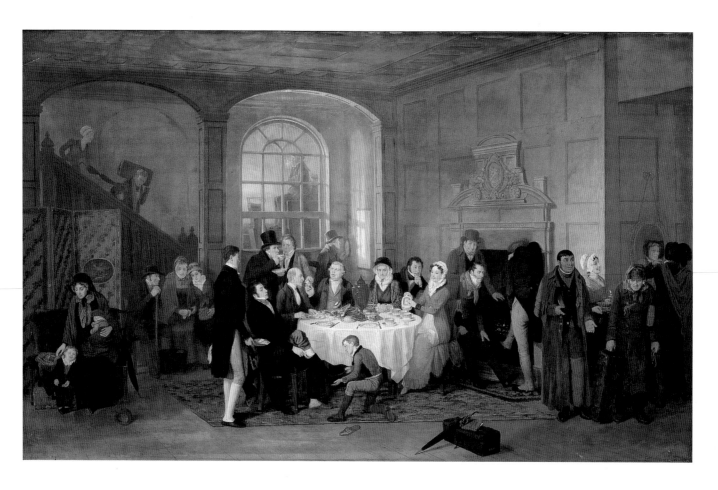

Edward Villiers Rippingille (1798–1859) *The Travellers' Breakfast*, 1824 CLEVEDON COURT, SOMERSET (Elton Collection)

'It is a fact that has been ascertained by actual experiment, that artists will die of starvation if they are not fed,' the Bristol painter E.V. Rippingille once remarked bitterly. He was his own worst enemy, nicknamed 'Rip Van Winkel' for his sloth, but when he found a generous local patron like Sir Charles Elton, he could be spurred to remarkably successful results.

The Travellers' Breakfast portrays the Elton family and their literary friends, many of whom lived locally and were contributors to the *London Magazine*, which had been founded four years earlier. Sir Charles himself stands warming his hands by the fire with a mischievous grin on his face. In front of him sits the Bristol publisher Joseph Cottle. The essayist Charles Lamb is the waiter handing a worried-looking Rippingille the bill for breakfast. Coleridge gives a boiled egg to Wordsworth to sniff: in the late 1790s Coleridge had been living nearby at Nether Stowey in Somerset (now also the property of the National Trust), Wordsworth at Alfoxden with his sister Dorothy. She is the woman in the black bonnet who looks on disapprovingly, as the third of the Lake Poets with Bristol connections, Robert Southey, attempts to chat up Sir Charles's pretty daughter, Lucy Caro- line. Rippingille himself was much smitten by the Elton daughters: Julia Elizabeth stands at the top of the stairs poking an unfortunate servant with an umbrella; Laura Mary leans on the shoulder of an old lady at the bottom of the stairs; on the far right, Caroline Lucy chuckles as the ostler tries unsuccessfully to extract a tip. On the far left Sir Charles's wife Sarah looks down at her young son, Arthur Hallam Elton, named in memory of Sir Charles's nephew and Tennyson's closest friend, whose tragic death in 1833 inspired the latter's poem *In Memoriam* and who is buried in the Elton vault in St Andrew's church, Clevedon.

Helen Allingham (1848–1926) *Thomas Carlyle reading in the Drawing Room*, 1879

CARLYLE'S HOUSE, LONDON (Carlyle Collection)

Carlyle's wife, the frugal, bored, unhappy Jane, was dead. The tall terraced house in Cheyne Row that they had bought together back in 1834 and filled with their plain Scottish furniture, had grown quiet. The talk that had enlivened these sombre rooms, the talk of Dickens and Thackeray, Tennyson and Browning, Ruskin and Darwin, all that was gone.

In his diary for early 1881 Helen Allingham's husband William described Carlyle's final days:

After taking finally to his bed the venerable man hardly spoke at all; but there was no physical obstruction of the organs of speech, but almost total absence of will or wish to say anything. Sometimes when Mary [Carlyle's niece] was doing something for him he would say, in a low tone, 'Ah, poor little woman.' He was heard to say 'Poor little Tommy' – thinking of his grand-nephew of a few months old. Once, he supposed the female hands that tended him, lifting his head perhaps, to be those of his good old Mother – 'Ah, Mother, is it you?' he murmured, or some such words. I think it was on the day before the last day that Mary heard him saying to himself, 'So this is Death: well–'. The 'well!' pronounced as if meaning, 'So be it! we shall see what it is like.'

Carlyle finally died at 8.30 on the morning of 5 February 1881.

Henry Hetherington Emmerson (1831–95)

William Armstrong in the
Dining Room at Cragside, c.1880

CRAGSIDE, NORTHUMBERLAND

(Armstrong Collection)

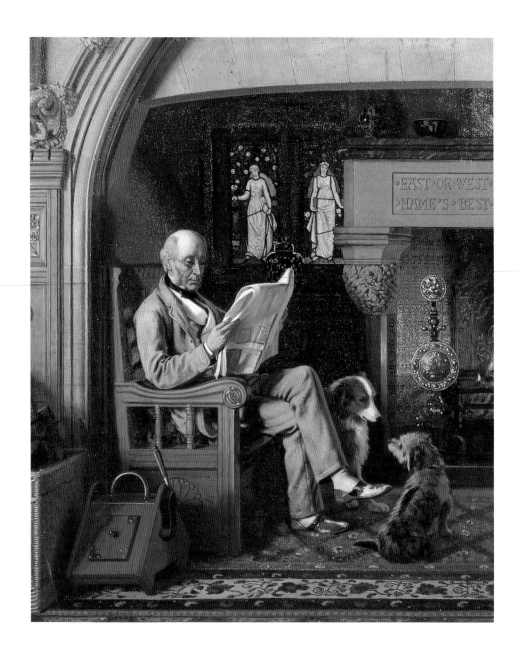

An elderly gentleman reads the newspaper by the fire, relaxed in country clothes and comfy slippers. A favourite collie and terrier sit at his feet, the coal scuttle and shovel ready at his elbow, if the fire needs encouragement. An ordinary picture of comfortable mid-Victorian domestic life, one might think. But this is Sir William Armstrong, a far from ordinary Victorian.

Engineer, inventor, gunmaker and industrialist on a titanic scale, Armstrong helped to transform the economy of the North East in the nineteenth century. From the fruits of his efforts he had Richard Norman Shaw build him a country retreat in the picturesque 'Old English' style on his Rothbury estate north of Newcastle. It was Shaw who designed the huge inglenook fireplace in the Dining Room, where Armstrong is sitting. He also inserted the Morris & Co. stained-glass maidens, representing the seasons, and the oak settle, carved on the arms with pomegranates, a favourite Pre-Raphaelite fruit.

And Armstrong reads not by daylight, but by his friend Joseph Swan's incandescent electric lights, which had been installed at Cragside very shortly before this picture was painted by Armstrong's favourite artist, the Northumbrian H. H. Emmerson. Armstrong the inventor was fascinated by the practical applications of electricity, and ensured that Cragside was one of the first homes in the world to be lit in this way. He found other uses for electricity as well. Just visible at the extreme left of Emmerson's painting is the electric bell button with which Armstrong could summon a servant.

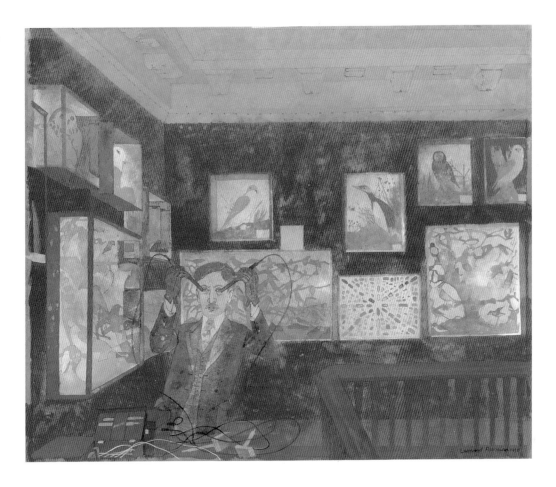

Leonard Rosoman (b.1913) *Otto Overbeck and his Rejuvenator*, 1990 OVERBECK'S, DEVON (Foundation for Art)

Nobody really enjoys getting older, and many fortunes have been made attempting to persuade people that they can reverse this inevitable process. One of the more remarkable characters to cater for human vanity was Otto Christoph Joseph Gerhardt Ludwig Overbeck. Although born in England, his background was decidedly cosmopolitan, having Dutch, Italian, French and Prussian grandparents. He earned his living working as a research chemist for a Grimsby brewery, where he created a non-alcoholic beer. Unfortunately, the excise office was determined to tax his new drink like ordinary beer, and so it never went into commercial production.

Undaunted, he devoted his spare time to perfecting an electrical 'rejuvenator'. This ingenious device generated an electric current, which was applied to the skin through various different-shaped metal tongs. Overbeck himself vouched for the successful results of his invention in the *Daily Graphic* in 1925:

Since completing my apparatus and using it on myself, I have practically renewed my youth. My age is 64 years, but I feel more like a man of 30 and am mentally more alert. My muscles and skin are those of a young man.

He patented the machine, which was very popular in the 1920s, and in 1926 was able to move from Grimsby to comfortable retirement in the warmer climate of the Salcombe estuary on the south Devon coast. Here he extended an already impressive Mediterranean garden and filled his home with a diverse collection, which ranges from children's bonnets and mementoes of the Salcombe boat-building industry to stuffed animals (some of which appear in this painting). He lived on at Sharpitor, none the worse for his electrical experiments on himself, reaching the age of 76, when he bequeathed the garden, house and contents to the Trust.

People [17]

Augustus John (1878–1961)

George Bernard Shaw, 1915

SHAW'S CORNER, AYOT ST LAWRENCE,

HERTFORDSHIRE (Shaw Collection)

3 April 1902

Mr Bernard Shaw's compliments to Miss Ellen
Terry.

Mr Bernard Shaw has been approached by Mrs
Langtry with a view to the immediate and
splendid production of Captain Brassbound's
Conversion at the Imperial Theatre.

Mr Bernard Shaw, with the last flash of a
trampled out love, has repulsed Mrs Langtry
with a petulance bordering on brutality.

Mr Bernard Shaw has been actuated in this
ungentlemanly and unbusinesslike course
by an angry desire to seize Miss Ellen Terry
by the hair and make her play Lady Cicely.

Mr Bernard Shaw would be glad to know
whether Miss Ellen Terry wishes to play
Martha at the Lyceum instead.

Mr Bernard Shaw will go to the length of
keeping a minor part open for Sir Henry
Irving when Faust fails, if Miss Ellen Terry
desires it.

Mr Bernard Shaw lives in daily fear of Mrs
Langtry recovering sufficiently from her
natural resentment of his ill manners to
reopen the subject.

Mr Bernard Shaw begs Miss Ellen Terry to
answer this letter.

Mr Bernard Shaw is looking for a new cottage
or home in the country and wants advice on
the subject.

Mr Bernard Shaw craves for the sight of Miss
Ellen Terry's once familiar handwriting.

G.B.S.

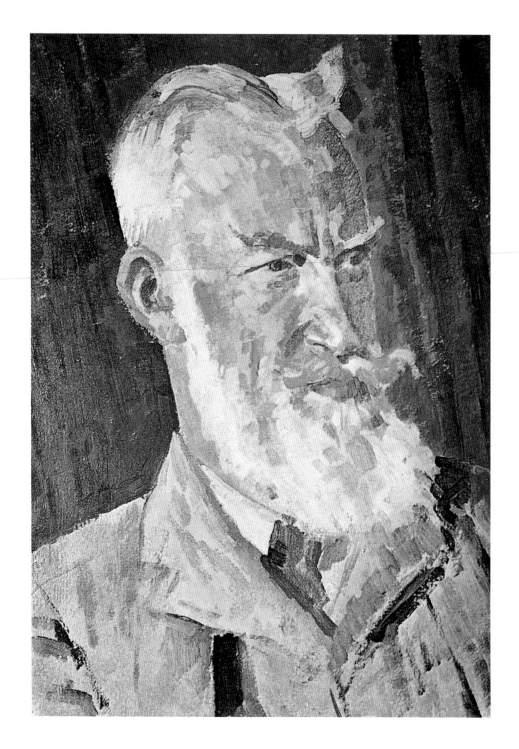

Playbill for
'Captain Brassbound's Conversion'

5 April 1902

"Mr Bernard Shaw has been approached by
Mrs Langtry" – Don't break her heart along
with the rest but let her have the play. You
write great plays and always ruin them with
the first start off. You have no powers of
selection. You know everything. You know
nothing.

　You are a great man.
　You are "a silly Ass".
　You are a dear.
　You are a "worry".
　Poor Charlotte!*
(*That's envy, isn't it?)

　　　　　　　　Your ownest ELLEN
My love to Charlotte [Shaw] and her husband.

Ellen Terry was eventually persuaded to play
Lady Cicely in March 1906, with the American
actor James Carew (to whom she was later
briefly married) as Captain Kearney.

　Terry died in 1928 at Smallhythe Place,
which had been her country home since 1899
and which her daughter was to give to the
National Trust as a permanent memorial to
her. Among her papers was found a note
labelled 'My Friends'. Shaw's was the second
name on it. His defiantly unbeautiful villa in
Ayot St Lawrence is also now in the care of
the Trust.

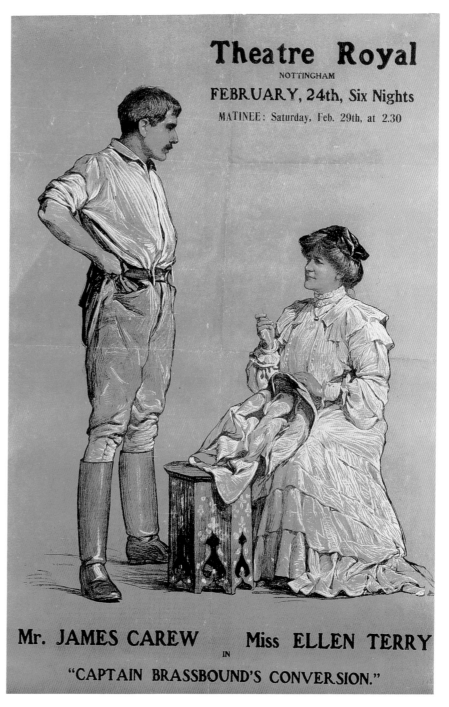

Rex Whistler (1905–44)

At work on the Plas Newydd mural, 1936

PLAS NEWYDD, ANGLESEY

(Anglesey Collection)

'I've never seen Rex *enjoy* a piece of work so ardently. His face lights when he speaks of it,' wrote Edith Sitwell of Whistler's masterpiece, a 58-foot-long mural destined for Plas Newydd, Lord Anglesey's recently modernised home on the Menai Strait. Whistler had just come from an all-night session on the huge canvas in a theatre workshop in Lambeth. His enjoyment of the job was all the greater because the studio was equipped with a scene-painter's adjustable frame, which enabled him to work on any part of the picture without back-breaking contortions. Self-mocking sketches in his letters to Charles Anglesey made the point.

In June 1937 the single seamless length of canvas was rolled up and brought to Plas Newydd, to be installed in the Marquess's new Dining Room. Whistler's sunny vision of a Mediterranean sea-port, a mixture of real buildings, erudite fantasy and jokey references to the Paget family, who were close friends as well as patrons, perfectly complements the spectacular Snowdonia landscape that can be seen through the windows opposite. To complete the room, he painted further scenes on the other two walls, including a self-portrait that now stands as a memorial to him. In July 1944 he was killed in Normandy, fighting with the Guards Armoured Division (whose emblem he had designed). He was 39.

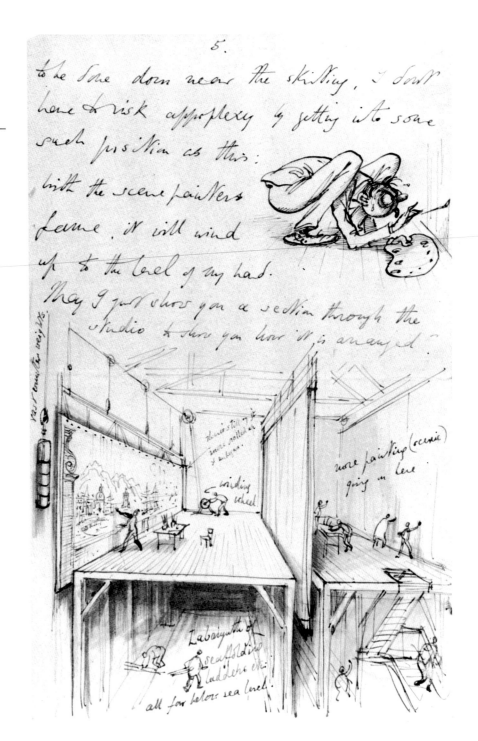

Rex Whistler (1905–44)

Self-portrait, 1937

PLAS NEWYDD, ANGLESEY

(Anglesey Collection)

Edward Halliday (b.1902)

Evelyn, Duchess of Devonshire repairing a tapestry in the High Great Chamber at Hardwick, 1950

HARDWICK HALL, DERBYSHIRE

(Devonshire Collection)

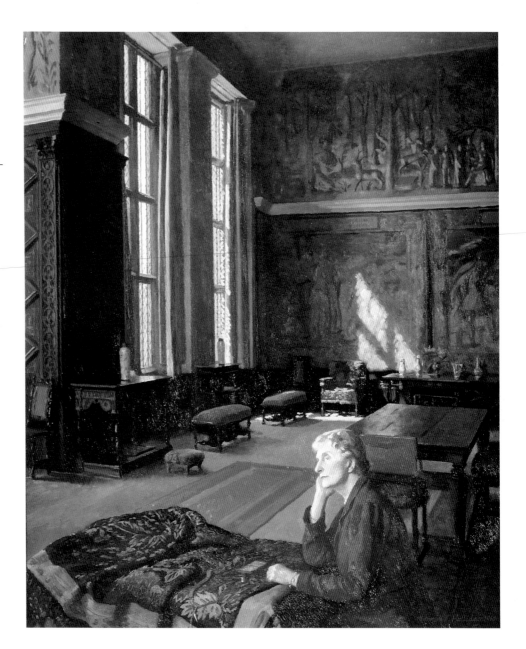

By the early twentieth century the Dukes of Devonshire owned Chatsworth in Derbyshire, Devonshire House and Chiswick House in London, Bolton Abbey in Yorkshire and Lismore Castle in Co. Waterford. It is not surprising therefore that they should have occupied Bess of Hardwick's Tudor prodigy house for only a few weeks each year. However, when Evelyn, wife of the 9th Duke, was widowed in 1938, she decided to make Hardwick her dower-house. Impervious to the cold, she would sit under the steady north light of the bay window in the Low Great Chamber (now the Dining Room), carefully repairing the incomparable collection of tapestries and embroideries. Her daughter Maud has described the regime of 'make do and mend' which, for good and ill, has always been such an important part of the English country house life:

Mr Green, the upholsterer, . . . prided himself that he had never bought any new materials for patching or lining, but had always 'used up some of the old'. This economy had a particularly disastrous effect on some of the tapestry, which was ruthlessly cut to fit the staircase walls. During the last few years of my mother's life at Hardwick, we reconstructed a large panel (complete with the exception of one border) of Verdure tapestry. It was in 25 different pieces, and the assembling was quite fascinating, a combined game of hunt-the-thimble and a jig-saw puzzle. I spent many hours on hands and knees tacking the 25 pieces together. My mother, who was a beautiful needlewoman, worked the joints till they were almost indistinguishable from the original weave. When all else failed, she painted in the missing pieces on beige repp of a rough texture, and one has to look very closely to distinguish the fake from the original.

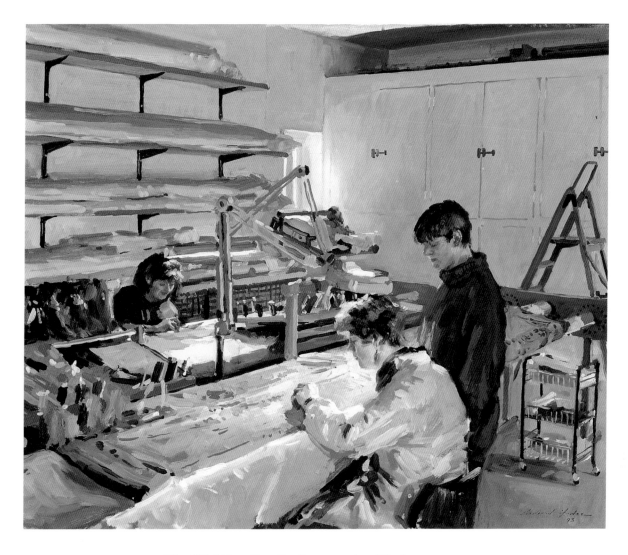

Richard Foster (b.1945) *The Blickling Textile Conservation Workroom*, 1993 FOUNDATION FOR ART

The work of Evelyn, Duchess of Devonshire is carried on by the National Trust in its specialist textile conservation workshops at Hughenden Manor in Buckinghamshire and Blickling Hall in Norfolk. Ksynia Marko, the manager of the Blickling studio, describes the qualities that are required of a textile conservator today:

The day-to-day work is pure hard slog; you have to be prepared to sit at a tapestry for eight hours non-stop. You also need to be flexible and have quite a strong stomach; earlier this year we had some curtains which had been urinated and defecated on by dogs and we had to put on masks and gloves to pick off the faeces. You might spend hours just vacuum-cleaning or perched on top of scaffolding to work on tapestries.

Conservation is, by definition, a practical subject. Unless you can handle an object you might as well not start, and it's no good being frightened of a textile or too precious about it either. Obviously the theoretical side is important, but at the end of the day you've got to get on and do the job.

Norman Ackroyd (b.1938) *On Long Mynd, Shropshire,* 1993 PRIVATE COLLECTION

CHAPTER TWO

COUNTRYSIDE

Ever charming, ever new,
When will the landscape tire the view!
The fountain's fall, the river's flow,
The woody valleys, warm and low;
The windy summit, wild and high,
Roughly rushing on the sky!

From John Dyer's
'On Grongar Hill', 1726

George Lambert (1700–65)

A View of Box Hill, Surrey, 1733

TATE GALLERY, LONDON

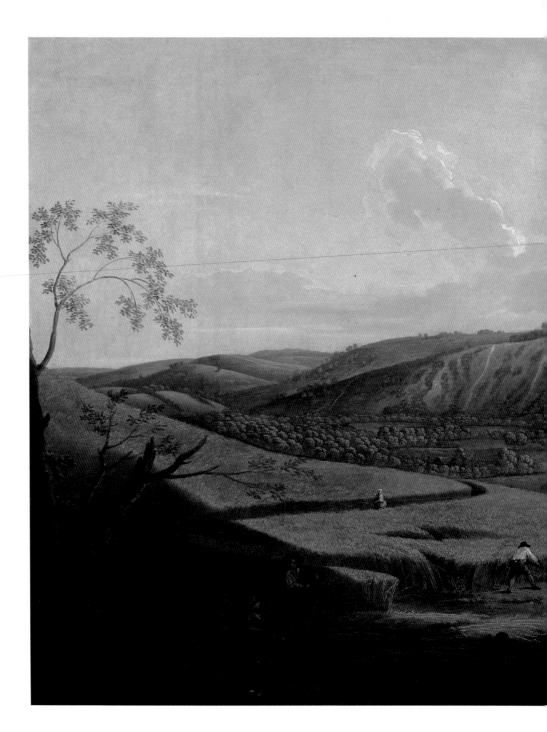

'The best air in England' was the verdict of
Sarah, Duchess of Marlborough on Box Hill,
when she stayed with her daughter nearby in
1732. The following year George Lambert
painted this view of the 400-foot-high chalk
escarpment from Ranmore Common (now
also the property of the National Trust).
Lambert is perhaps the man sitting in the
foreground with a drawing-board. To the
left are the Mickleham Downs; to the right
the Mole Gap, through which runs the
River Mole.

Celia Fiennes noted the box trees from
which the hill takes its name and which still
clothe its western slopes, when she passed this
way around 1694. Earlier that century the Earl
of Arundel had cut ornamental walks through
these woods which proved popular with
courting couples. It was 'very easy', as John
Macky remarked in 1714, 'for Gentlemen
and Ladies insensibly to lose their company
in these pretty labyrinths of Box-wood, and
divert themselves unperceived . . . and it
may justly be called the Palace of Venus.'

Macky's dallying lovers would hardly
recognise the view from Box Hill today, as
Dorking has grown to swallow Lambert's
cornfields. Since 1914 the Trust has been
gradually acquiring parcels of land on the
hill to protect it from development. *Country
Life* has been a valuable ally in this endeavour,
in 1923 launching a campaign to preserve a
further 248 acres, which brought in
contributions large and small from all over
the world, including 1s 6d from an
unemployed ex-serviceman in Plymouth.
Today Box Hill is safe from all but natural
disasters like the Great Storm of 1987, which
tore down many of the ancient beeches on the
summit. In that respect at least the landscape
now resembles more closely Lambert's
sparsely wooded hillside.

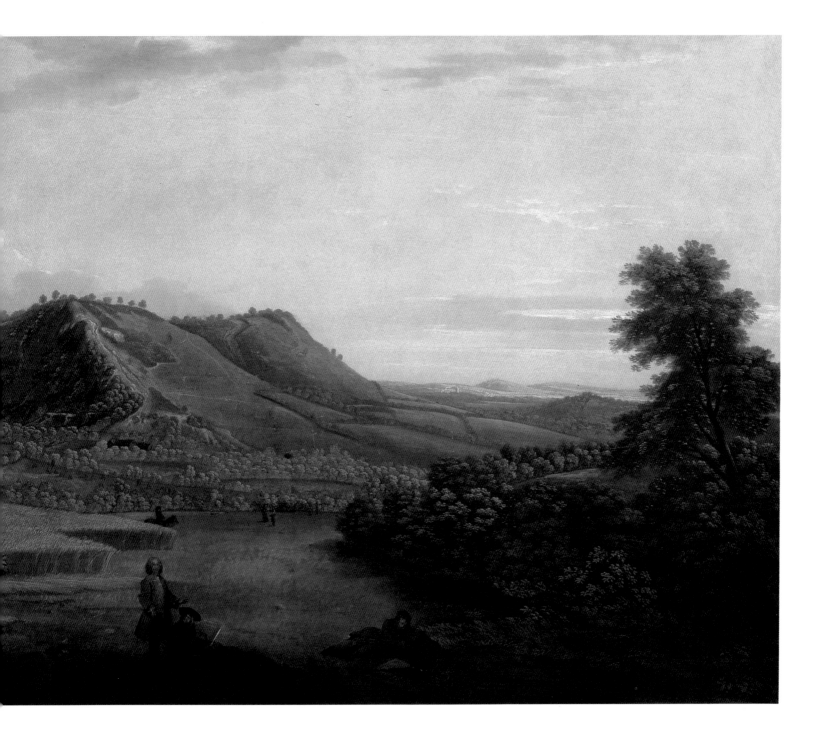

Richard Wilson (1713/14–82)

Lydford Waterfall, Tavistock,
*c.*1771–2

NATIONAL MUSEUM OF WALES,
CARDIFF

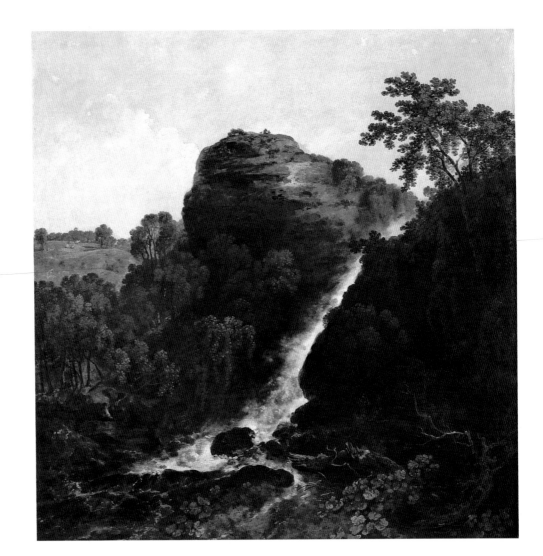

Richard Wilson's career is a grim warning of the fragility of the creative life in the face of changing fashion. At the beginning of the 1770s he was at the height of his profession, having just been elected a founder member of the Royal Academy. Within two or three years he was practically destitute, dependent on the charity of the RA and plaintively asking his fellow artist James Barry 'if he knew anyone mad enough to employ a landscape painter, and, if so, would he recommend him.' As he turned 60, he became ill and made matters worse by taking to drink: he was ridiculed as a 'Malmsey butt' for his florid features.

In the summer of 1771 he seems to have been invited to paint Okehampton Castle and Lydford Gorge in west Devon by the local magnate, Viscount Courtenay. For some years the noise and movement of waterfalls had made them popular subjects for the up-and-coming artists who pioneered the Romantic sensibility. Wilson's stock-in-trade was rather different: calm views of ideal landscape bathed in the golden light of Italy. One can perhaps sense in *Lydford Waterfall* the ageing artist desperately attempting to come to terms with the new artistic fashion, and an overriding melancholy that is not simply a symptom of the new mood, but a bitter reflection on his own plight.

The wooded ravine of Lydford Gorge has been attracting artists and writers ever since for more cheerful reasons. Visitors today can enjoy crashing waterfalls and quiet pools amid pungent wild garlic along the 120-acre stretch which the National Trust protects.

Julius Caesar Ibbetson (1759–1817) *A Phaeton in a Thunderstorm*, 1798 LEEDS CITY ART GALLERIES

Looking for picturesque scenery could be a dicey business in the eighteenth century. According to the label Ibbetson attached to the back of this painting, it records 'An Actual Scene'. Ibbetson, with his fellow artist, John 'Warwick' Smith, and their patron, the Hon. Robert Fulke Greville, was touring North Wales in 1792. They were climbing the Aberglaslyn Pass between Tan-y-Bwlch and the stone bridge at Pont Aberglaslyn – a famous beauty spot – when they were engulfed by a thunderstorm. Their horses shied at the sudden noise and might have carried them off the road into the river below if Ibbetson had not had the presence of mind to leap down and wedge a rock behind the back wheel of their phaeton.

Antoine Benoist (1721–70) after Thomas Smith (d.1769) *A Prospect in Dove-Dale*

From *Eight of the most extraordinary Prospects in the mountainous Parts of Derbyshire and Staffordshire, commonly called the Peak and the Moorlands,* 1769

E. Rhodes defends the scenery of the Peak District against its critics in 1824:

Travellers accustomed to well wooded and highly cultivated scenes only, have frequently expressed a feeling bordering on disgust, at the bleak and barren appearance of the mountains in the Peak of Derbyshire; but to the man whose taste is unsophisticated by a fondness for artificial adornments, they possess superior interest, and impart more pleasing sensations. Remotely seen, they are often beautiful; many of their forms, even when near, are decidedly good; and in distance the features of rudeness, by which they are occasionally marked,

are softened down into general and harmonious masses. The graceful and long-continued outline which they present, the breadth of light and shadow that spreads over their extended surfaces, and the delightful colouring with which they are sometimes invested, never fail to attract the attention of the picturesque traveller. But there are persons who, unfortunately for themselves, cannot easily be pleased with what they see; and who, like Sterne's Smelfungus, can 'travel from Dan to Beersheba and cry "tis all barren" '.

The National Trust now protects over 35,000 acres of this 'barren' landscape.

W. H. Kelsall (active 1830s–1850s) after Thomas Allom (1804–72)

View from Langdale Pikes, Looking South-East, Westmorland
From Thomas Rose's *Westmorland, Cumberland, Durham, and Northumberland, Illustrated*, iii, 1835

This view left Thomas Rose almost, but not quite, lost for words:

An extensive and astonishing view of mountain scenery is obtained from the summit of the Pikes, looking in an easterly direction. The mountains of Fairfield, High Street, Hill Bell, Harter Fell, Potter Fell, and others, are here brought into view together, and form, with the lakes and tarns which diversify the scene, the most magnificent prospect on which the eye can rest.

Language is unequal to the task of describing the extensive scope of vision enjoyed from the summit of a mountain, or the splendid combination of sublime and pleasing objects at once presented to the eye. The following poetical extract embodies more of the *spirituel*, than, perhaps, any other we could have selected.

O 'tis an unimaginable sight!
Clouds, mists, streams, watery rocks, and emerald turf,
Clouds of all tincture, rocks and sapphire sky,
Confused, commingled, mutually inflamed,
Molten together, and composing thus,
Each lost in each . . .

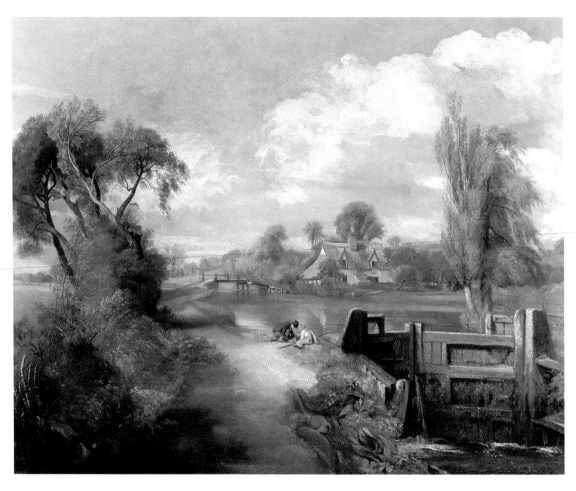

John Constable (1776–1837) *Boys Fishing*, 1813 ANGLESEY ABBEY, CAMBRIDGESHIRE (Fairhaven Collection)

I should paint my own places best - Painting is but another word for feeling. I associate my 'careless boyhood' to all that lies on the banks of the Stour. They made me a painter (& I am gratefull).

There is no place in Britain so closely associated with a single artist as the two miles of the Stour valley between Flatford and Dedham on the Suffolk/Essex border are with John Constable. Here he spent his youth and here, after settling in London, he returned every summer to sketch by the Stour.

The two young lads fishing recall Constable's 'careless boyhood', and much else is immediately recognisable from his other paintings. In the foreground water seeps through the leaky gates of Flatford Lock. Beyond are Bridge Cottage, the footbridge and dry-dock (now silted up). Just out of view to the right is the mill that belonged to his father, Golding Constable, and Willy Lott's House – thanks to *The Hay-Wain* in the National Gallery, perhaps the most famous building in the whole of British art.

The A12 dual carriageway has altered irreparably much of this tranquil landscape, but the heart of 'Constable Country' survives through the work of the National Trust and the Dedham Vale Project. The Trust has owned Flatford Mill and Willy Lott's House since 1943, and in 1985 it acquired Bridge Cottage, which continues to serve modest teas to the thousands of Constable lovers who come here each year. The buildings without the surrounding landscape would be meaningless, and so the Trust in 1992 extended its protection to a mile of the water-meadows between Flatford and Dedham.

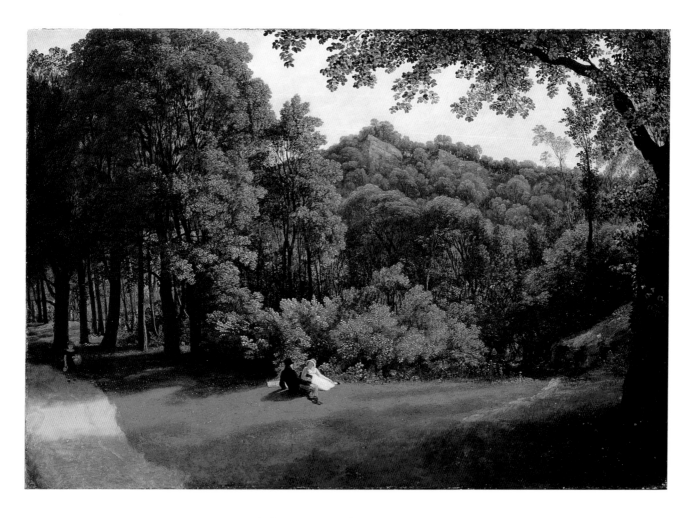

Francis Danby (1793–1861) *A Scene in Leigh Woods,* 1822 BRISTOL CITY ART GALLERY

Francis Danby described Leigh Woods, which lie on the south side of the Avon Gorge opposite Clifton, as 'an excellent place for painters to become acquainted'. Danby had arrived in Bristol as a penniless nineteen-year-old in 1813, and he soon became one of the most successful of the flourishing local group of artists that sketched together in Leigh Woods. The top-hatted gentleman sitting on the grass may well be a painter friend.

The Rev. John Eagles, a Bristol curate and amateur artist, praised the local scenery in verse:

Ye pleasant woods of Leigh, shall I
Again your happy tenant lie,
Sheltered beneath o'er-arching rock,
And trees that wildly shoot and lock
To form a green mysterious shade,
As if a fairy ambuscade
Beneath those trembling leaves were laid;
And silence breath'd intelligence,
And stocks and stones had living sense . . .

But he also analysed the vivid greens of June foliage in Leigh Woods with an intensity that matches Danby's painting:

They were of all shades, but rich as if every other colour had by turns blended with them, yet unmixed, so perfect in predominance was the green throughout. So varied likewise was the texture, whether effected by distance, by variety of shade, by opposition, or by character of ground. There was much of the emerald, not in colour only, but in its transparent depth.

Robert Walker Macbeth (1848–1910)

*Sedge Cutting in Wicken Fen,
Cambridgeshire: Early Morning,*
1878

Macbeth made his name with engravings of
contemporary rural life for the *Graphic*, which
from 1869 had been highlighting the grim
conditions of the poor in city and countryside.
When he exhibited this painting at the Royal
Academy in 1878, he added the following
commentary:

'Sedge cutting' is one of the remnants of a fen
industry, and Wicken Fen the only remaining
portion of a great fen district on which the
sedge has free growth. This fen is now reduced
to a small acreage by man and his agricultural
improvements, especially in drainage. But it
was, even to the present generation, a vast area
of fen, bog, and water, where myriads of water-
fowl made their home, and the booming of the
bittern was a common sound; where the
fenman dug his peat for fuel, and cut his sedge
for kindling his fire and covering his roof, while
at night he brooded over his fire and dreamt of
the 'Jack o' Lanterns', often, too, shivering
with ague fever, for although to the manner
born, yet even he was not free from the terrible
consequences of the fen miasma.

Wicken, which the Trust has steadily been
acquiring since 1899, is now almost the only
area of undrained fen left. Thankfully, the fen
ague has been banished, but the booming of the
bittern can still be heard.

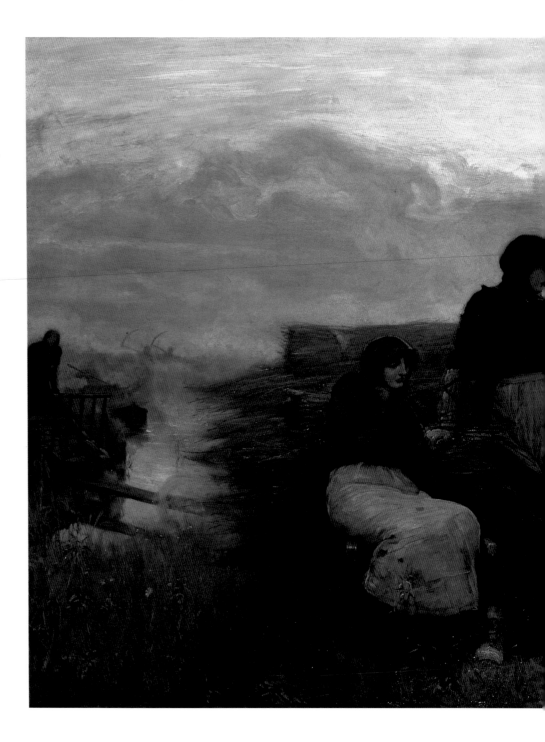

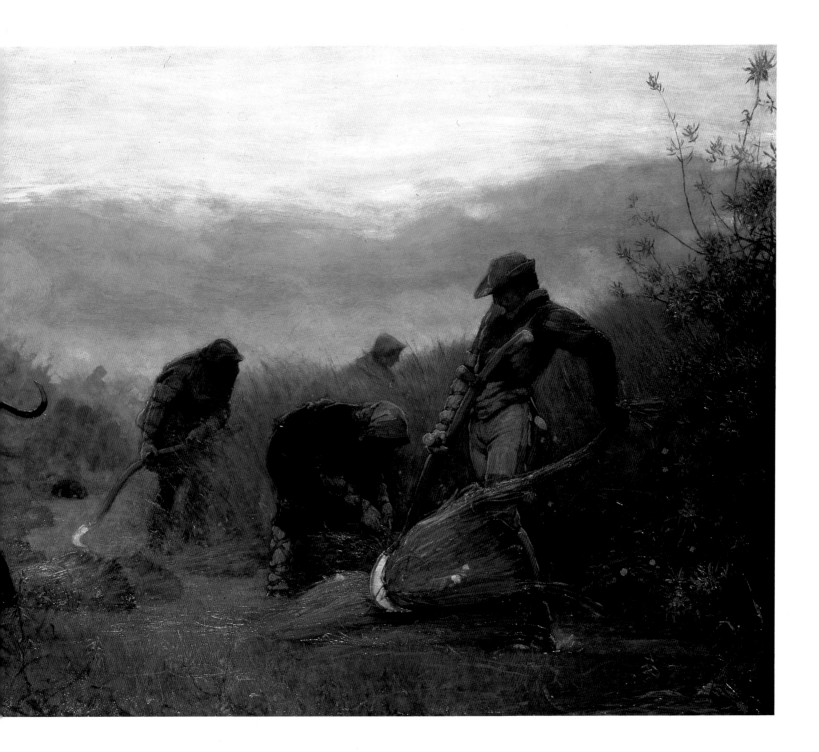

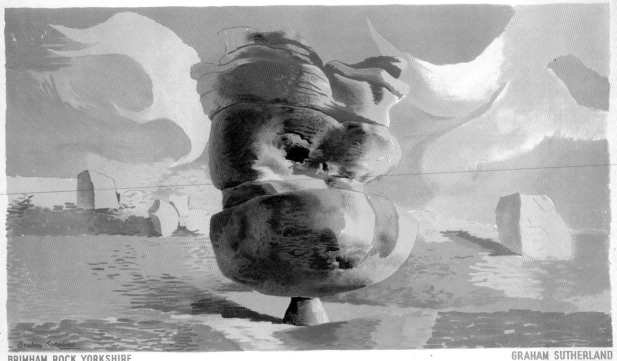

TO VISIT BRITAIN'S LANDMARKS

BRIMHAM ROCK, YORKSHIRE

GRAHAM SUTHERLAND

YOU CAN BE SURE OF SHELL

Graham Sutherland (1903–80) *Brimham Rock*, 1937 SHELL ARCHIVE, THE NATIONAL MOTOR MUSEUM, BEAULIEU, HAMPSHIRE

In the early 1930s, with the growth of mass motoring, advertising hoardings were springing up across the British countryside. The Council for the Preservation of Rural England began a campaign to check the spreading blight and found an unlikely ally in Shell Mex and BP Ltd. Its enterprising new Publicity Director, Jack Beddington, devised a series of posters that were pasted on to the company's petrol tankers rather than on hoardings, and chose young and often avant-garde artists to design them. In 1935 Sutherland was asked to paint the weirdly shaped rock formations at Brimham in Nidderdale, ten miles northwest of Harrogate. In an essay published two years later he described what he saw there:

Most singular of all is the huge conglomerate mass of stone to the right. . . . It is round in plan and divided into three distinct sections. The lowest and largest is shaped like a flattened sphere, rather broader than it is long, and the middle section is attended by much corrugation and eruption, which, extended to the section above, almost attains to an efflorescent character. The whole mass is poised, like an acrobat's ball on his stick, on a small inverted cone of stone.

The setting sun, as it were precipitating new colours, turns the stone, rising from its undulating bed of bright green moss and blackened heather, yellow, pink and vermilion.

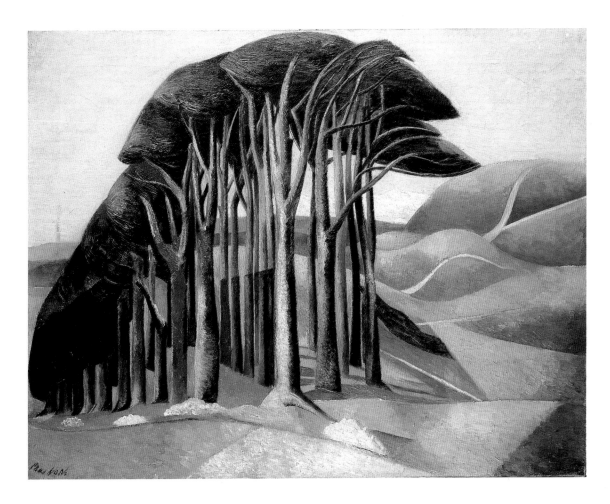

Paul Nash (1889–1946) *Wood on the Downs*, 1930 ABERDEEN ART GALLERY

There had been Nashes living in Buckinghamshire since the sixteenth century. In 1901 the twelve-year-old Paul Nash moved with his family into a new home that had been specially built for them, Wood Lane House at Iver Heath. The house was well named because the garden was dominated by a stand of tall and ancient elms that obsessed Nash, inspiring these teenage verses:

> O dreaming trees sunk in a swoon of sleep
> What have ye seen in those mysterious places?
> What images? What faces?
> What unknown pageant thro' these hollows moves
> At night? What blood fights have ye seen?
> What scenes of life & death? What haunted loves?

Such questions hardly needed asking of the shattered tree stumps that fill his most famous work, the Great War landscape entitled, with grim irony, *We are Making a New World*. The experience of the trenches scarred Nash and the rest of his generation for life. Nash himself found it easiest to express his feelings about the First World War indirectly through painting landscapes of trees. In 1929 his father, to whom he was very close, died and Wood Lane House was sold up. With his strong sense of family and place, he was drawn back to Buckinghamshire the following spring and to the Ivinghoe Beacon, one of the highest points on the 4,000-acre Ashridge estate and the subject of *Wood on the Downs*. 'The painting is simply a synthesis of a scene and mood of nature at a particular time of year – March,' he wrote. But it also celebrates his love of mature trees and their power to evoke the lost world of his Buckinghamshire ancestors.

Countryside [37]

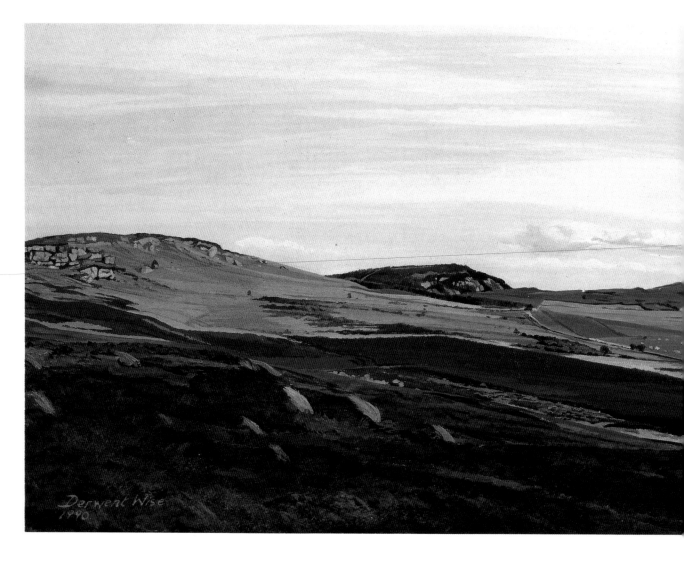

Derwent Wise (b.1933) *Distant View of Ross, Chillingham, Northumberland*, 1990
PRIVATE COLLECTION

Edward Grey, the man who watched 'the lamps . . . going out all over Europe' in 1914, spent eleven years as Foreign Secretary, but his first love was bird-watching and fishing on his family estate at Falloden in north Northumberland. Grey's favourite spot was the hill crowned by the Iron Age Ross Castle camp, from where there are superb views over Chillingham Park and north to the Cheviots. And it was here that he sought consolation following the tragic death of his wife Dorothy in a riding accident in February 1906, as he described to a friend:

I go out a good deal at Falloden; I took my bicycle over the moorland road from North Charlton and went to the top of Ross Camp one day; a year ago I trailed Dorothy over that road and round by Chillingham and Bellshill. This year too it was a beautiful day and I heard wonderful bird sounds, the spring notes of golden plovers and above all of curlews, as different from their autumn notes as the song of birds is from their chirp, and the sun was glorious and the whole view full of light. I was sad all day, seeing and listening to it all, but thinking and longing. Then in the evening after supper, when I was lying on the sofa in the library, the whole beauty of the day, of all I had seen and heard, seemed to find a way to me unawares and I became very peaceful.

Three years after Grey's death in 1933 the National Trust acquired the summit of Ross Castle hill – the central peak on the far horizon – as a permanent memorial to this devoted Northumbrian and great nature writer.

Charles Paget Wade (1883–1956) *The Beach at Great Yarmouth* SNOWSHILL MANOR, GLOUCESTERSHIRE (Wade Collection)

CHAPTER THREE

COASTLINE

Oh I do love to be beside the sea-side,
I do love to be beside the sea.
I do love to walk along the prom-prom-prom,
With the brass band playing tiddley-om-pom-pom.

John A. Glover-Kind

Susanna Drury (active 1733–70)

Giant's Causeway, c.1740

ULSTER MUSEUM, BELFAST

In 1740 Susanna Drury, a young Dublin artist,
submitted two 'prospects' of the Giant's
Causeway in Co. Antrim to the exhibition of
the newly formed Dublin Society. Not
surprisingly, she carried off the first prize,
for her panoramic views, painted in gouache
on vellum, not only capture the drama of this
extraordinary geological formation, but also
provide a remarkably faithful record of it. The
engravings after her paintings by Francis
Vivarès were a great success, being reissued
several times, and helped to stimulate scientific
curiosity about the origins of the Giant's
Causeway. The 'Neptunists' believed that the
honeycomb of hexagonal columns had been
formed on the seabed by compacted mud. The
'Volcanists' argued that they were the result of
volcanic action – the view taken by modern
scientific opinion.

 Vivarès's engravings did more for the Giant's
Causeway than for Susanna Drury. Like most
female artists before the nineteenth century, she
remains a sadly shadowy figure, known only by
these, her 'master'pieces. By contrast, the
Causeway soon became one of the most popular
tourist attractions in Ulster, with stalls set up
among the rocks to entice visitors. The National
Trust, which was given the Causeway in 1961,
has been living with the consequences of that
popularity ever since.

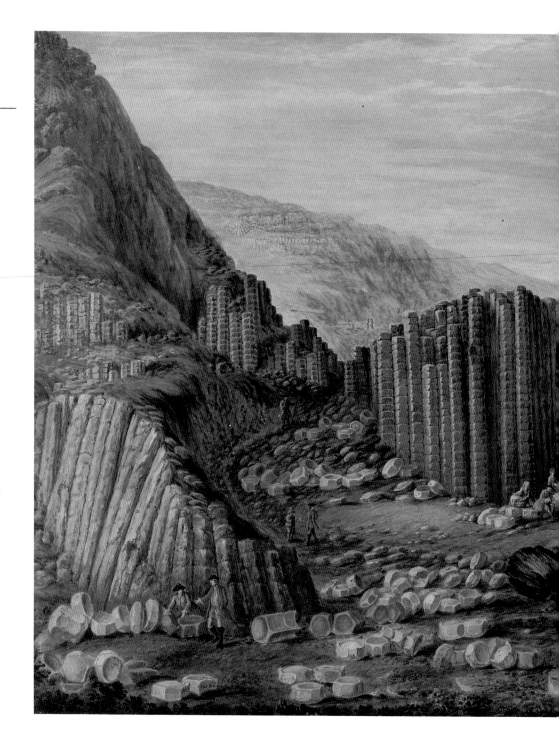

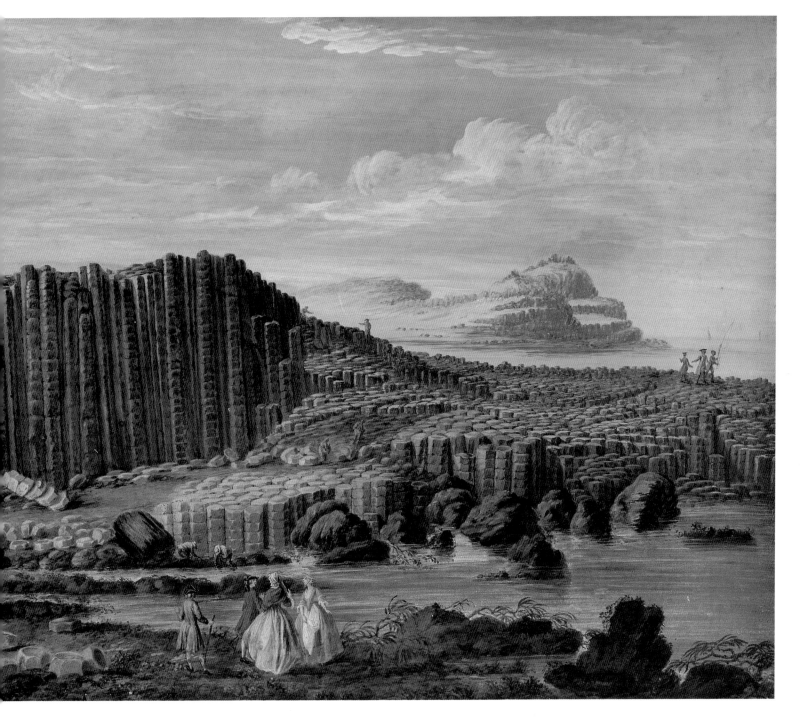

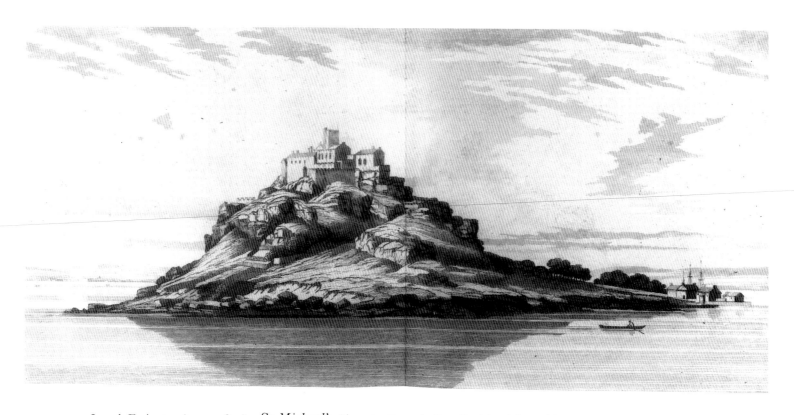

Joseph Farington (1747–1821) *St Michael's Mount* From the Rev. Daniel and Samuel Lysons's *Magna Britannia*, 1814

On Friday, 7 September 1810 Joseph Farington put up at the Star Inn at Marazion in Cornwall. The inn enjoyed a spectacular view of St Michael's Mount and he was up at six the next morning to sketch it:

I next hired a Boat with two Fishermen to take me round the Island, which they undertook to do and to allow me time for making sketches, for a reward of four shillings. The weather was very fine, & the sea sufficiently smooth to enable them to keep the boat nearly stationary wherever I chose to remain. This rock, with its Castle, is a noble subject for a painter. The west front of it which faces the Ocean is the most rugged and precipitous. The form & the Colour of it is beautiful, & all the parts are so much in unison, the Castle is in all respects in such harmony with the rock upon which it stands, as almost to seem a natural part of it. The general colour of the rock is grey of various degrees; such also is that of the Castle; but in both there is a mixture of other tints which by their opposition give greater effect to the whole. The Herbage which forms a part of the surface is of a mild and subdued colour, well agreeing with the grave hue of the castle and rock. . .

I passed a considerable time in contemplating the Island from various points & in sketching; & my Boatmen being satisfied with the bargain they had made, & being young and cheerful, they sung, while I pursued my purpose.

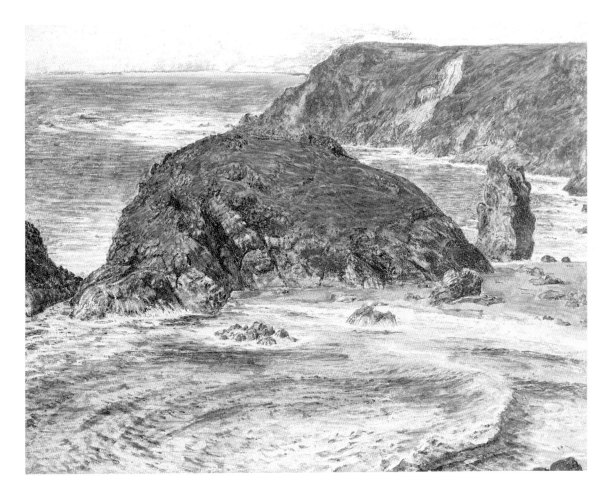

William Holman Hunt (1827–1910) *Kynance Cove, Cornwall*, 1860 PRIVATE COLLECTION

In September 1860 Holman Hunt and his painter friend, Val Prinsep, joined the Poet Laureate, Alfred Tennyson, and the compiler of the *Golden Treasury*, Francis Palgrave, for a walking holiday in the West Country. They stopped at Kynance Cove on the Lizard peninsula to enjoy the view, as Hunt recalled:

We painters had placed ourselves upon a tongue of cliff which divided a large bight into two smaller bays; thence we could, to right and left, see down to the emerald waves breaking with foam white as snow on to the porphyry rocks. Our seats were approached by a shelving saddle of a kind that required keen sight and firm feet to tread.

A sudden gust of wind almost carried Hunt's watercolour over the cliff, but he managed to rescue it with his umbrella. Emily Tennyson was anxious that her very short-sighted husband might also be blown over the precipice and asked Palgrave to keep an eye on him, much to Tennyson's annoyance:

The poet had made up his mind to look down into the gulf, and we had to find an abutting crag over which he could lean and survey the scene. In the original sense of the word, he was truly nervous, but looked steadily and scrutinisingly. The gulls and choughs were whirling about to the tune of their music, with the pulsing sea acting as bass, and it was difficult for eye or ear to decide whether the sound or the sight were most delightful. Tennyson, when led away to a broader and safer standpoint, said, 'I could have stayed there all day.'

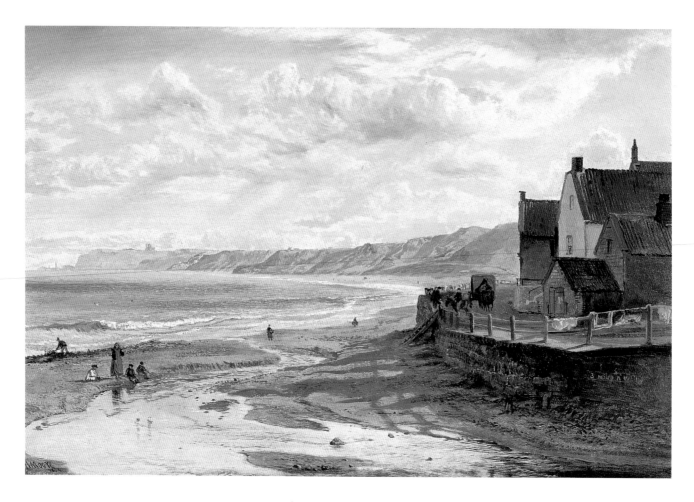

Henry Moore (1831–95) *Robin Hood's Bay*, 1864 CHRISTOPHER NEWALL

Leo Walmsley arrived in Robin Hood's Bay on the Yorkshire coast in 1895 at the age of three:

We had come because a friend of Dad's (another artist) had been to the place for his summer holidays, and he had raved about it so much that Dad thought he would come and have a look at it. He thought it was the most beautiful place he had ever seen, and that if we could live in it for just a year or two, he'd be able to make a name for himself and paint and sell enough pictures for me to have a good education, and for him and mother to go to Paris, and Italy and other places where he could paint and earn more fame and money.

His father was to be disappointed:

Dad earned money in summer, selling water-colour sketches to the visitors. He didn't like painting these pictures, because the most popular subjects were those showing as much of the place as possible, for people to remember it by when they had gone away, while the subjects which he called really picturesque, like the Ship Inn, no one seemed to want.

Nevertheless father and son loved Robin Hood's Bay. As a child Leo explored the creeks and pools of the bay and got to know the local fishermen. Later he campaigned to preserve their precarious industry in a series of auto-biographical novels, including *Three Fevers* (1932), *Phantom Lobster* (1933) and *Foreigners* (1935), which describe life in 'Bramblewick', as he called Robin Hood's Bay.

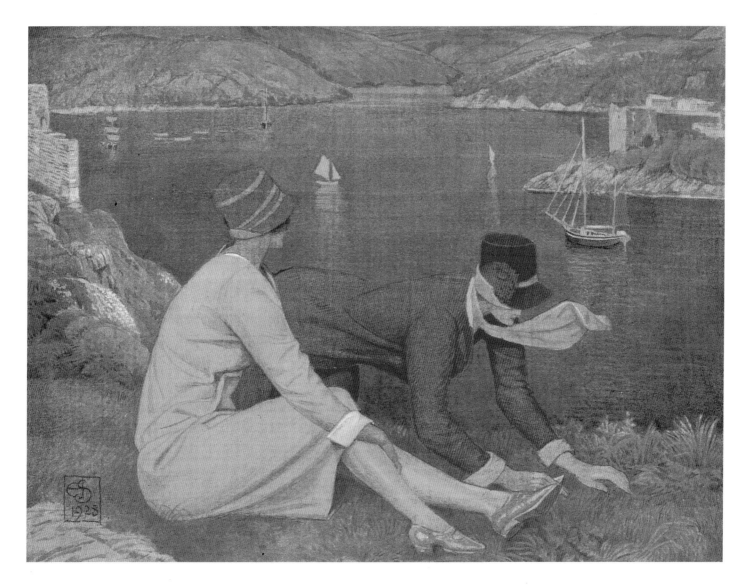

Joseph Southall (1861–1944) *The Botanists*, 1928 HEREFORD CITY MUSEUMS AND ART GALLERIES

Joseph Southall loved to paint water and every year he would leave his native Birmingham to visit the Suffolk beaches of Southwold or the rocky Cornish estuary of Fowey with his wife Anna. Because the couple were blood relatives, they decided not to have children and perhaps for that reason particularly enjoyed the company of the young. Fashionable cloche hats disguise the identity of Southall's elegant young botanists, but there is no mistaking the view from the promontory above Readymoney Beach across Fowey harbour to the old blockhouse and Polruan on the right, painted with Southall's typical precision in tempera on silk. And although no sensible person picks wild flowers any longer, this view can still be enjoyed, thanks to the energetic works of the National Trust in Cornwall, which acquired much of the shoreline shown here through the Enterprise Neptune campaign.

Austin Frazer

Quayside Orfordness towards Orford Castle, 1945

THE NATIONAL TRUST (Orfordness Collection)

Austin Frazer describes his time at Orfordness:

During the occupation of Orfordness by the Aeroplane & Armament Experimental Establishment in the Second World War, a tall gantry was erected in order to test reputedly leakproof petrol tanks taken from Japanese planes. The gantry gave superb views over the whole of Orfordness but reaching the small platform at the top necessitated climbing the outside of the structure on steel tubes some eighteen inches apart.

I was the film and photo boffin recording 'strikes' – bullets and cannon shells of various types fired into fuselages, engines and armaments hung under wings. I had arrived in Suffolk from Warwickshire where I had been an aerial photographer of civilian camouflage sites. After that Mickey Mouse county the mighty Suffolk skies filled me with something akin to joy, but they were transitory for an off-duty painter working in watercolour. In the foreground of the view are the aircraft used in these armament experiments; beyond, at full tide, is the River Ore covering the King's Marshes; and, in the centre on the mainland, the snaggle tooth of Orford Castle. The regularly spaced blobs are concrete blocks placed to dissuade enemy aircraft from landing.

The gantry became my favourite look-out. I overcame my initial fear of heights by climbing it daily with a heavy film camera strapped to my back. The day of the first test firing I was in position focused on the tank. I gave the order to fire. The tank exploded and enveloped the gantry in flames which passed over me as I crouched down. Some hours later, when the steel had cooled, I climbed down – unharmed and cooled off myself by then.

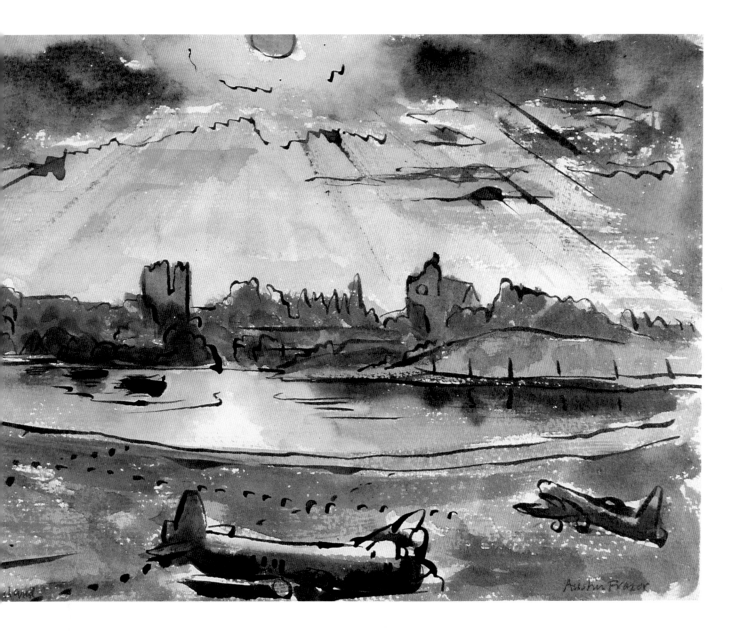

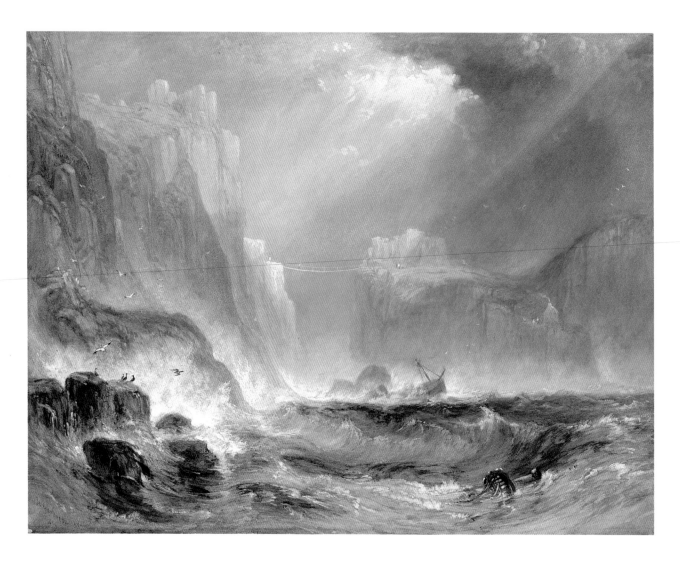

Henry Gastineau (1791–1876) *Carrick-y-Rede, Antrim*, 1839 BIRMINGHAM MUSEUMS AND ART GALLERY

In 1891 the French writer and traveller Marie-Anne de Bovet published her account of *Trois Mois en Irlande*:

Seen from a distance, the peculiar islet of Carrick-a-rede looks like a fortress, but, as its name indicates, it is only a 'rock in the way'. It is a huge block of basalt, which stops the salmon that are going along the coast, and catches them in a sort of natural trap, whence they are taken in considerable numbers.

The bold traveller makes it a point of honour to cross the swinging bridge, made of two parallel ropes bound together by light cross-pieces, and with a third rope for hand-rail. The bridge connects the islet with the land, and is thrown over a chasm twenty yards wide by thirty deep. All who have tried it have repented of their temerity before reaching the middle. If sensation is all that is required, it is only necessary to look at the women and boys engaged in the fishery almost running across it, and that, too, while laden with a big basket, and with the bridge swaying in the wind like a swing.

Len Tabner (b.1946) *Lindisfarne from Ross Sanas* FOUNDATION FOR ART

Many films have been shot on National Trust land; few have been anything like Roman Polanski's *Cul de Sac*. It tells the story of a middle-aged Englishman living in a remote and seedy island castle with his second and much younger wife, who proceeds to cuckold and otherwise humiliate him with a group of sinister intruders. To scout out locations, Polanski climbed into a plane and flew up the east coast of England until he spotted Holy Island off the Northumbrian coast. The island is dominated by Lindisfarne Castle, the sixteenth-century fortress transformed in 1903 by Edwin Lutyens as a holiday home for Edward Hudson, the owner of *Country Life*. This, he thought, would be ideal.

It was 1966, when film stars behaved like film stars. Donald Pleasence, who played the Englishman, arrived on the island in a huge American automobile, much to the bemusement of the locals. Françoise Dorléac, who played his wife, brought seventeen suitcases of luggage and an evil-tempered lapdog called Jaderane that took an instant dislike to Polanski. Making the film proved an ordeal for all concerned. The weather was awful, and the remoteness of Holy Island unsettled a cast and crew more used to the comforts of Swinging London. Polanski was already notorious for his low opinion of actors and for the physical demands he made of them. Running behind schedule, he decided to

shoot one key scene as a single, eight-minute take. This entailed Françoise Dorléac stripping naked, plunging into the icy waters of the North Sea and remaining there throughout the scene. When she emerged, her body was blue with cold. Nevertheless, Polanski demanded another take, and then another, during which Dorléac collapsed with exhaustion.

The normally phlegmatic British film crew downed tools in protest at Polanski's behaviour, and he had to relent. The final scene of the film shows Dorléac running away across the beach as the rising tide cuts off the island from the mainland. Well she might.

John Ruskin *Middle House and Dovecote, Malham Tarn, North Yorkshire*

From Ruskin's *Poetry of Architecture*, 1893

COTTAGES, BARNS AND SMALLER HOUSES

One of the principal charms of mountain scenery is its solitude. Now, just as silence is never perfect or deep without motion, solitude is never perfect without some vestige of life . . . One of the chief uses of the mountain cottage, paradoxical as it may appear, is to increase this sense of solitude.

John Ruskin,
The Poetry of Architecture, 1893

Anonymous *Great Coxwell Barn, Berkshire* From John Nichols's *Bibliotheca Topographica Britannica*, 1791–1800

In the church of St Giles in the village of Great Coxwell on the northern slopes of the Vale of the White Horse in Berkshire are two small brasses. Dating from about 1500 they commemorate William Morys, 'sumtyme fermer of Cokyswell', and his wife, Johane. The coincidence delighted William Morris, who decided to settle with his wife, another Jane, four miles away at Kelmscott in 1871. For Great Coxwell contains what Morris always considered was one of the finest buildings in the world, the thirteenth-century tithe barn: 'unapproachable in its dignity, as beautiful as a cathedral, yet with no ostentation of the builder's art.' In 1889 he paid another visit:

We went to Great Coxwell yesterday, and also to Little Coxwell, where there is a funny little church with a 14th-century wooden roof over the nave, the church much smaller than Kelmscott. We were delighted with the barn again. The farmer turned up and seemed a nice sort of chap; he said his family had been there for hundreds of years. William Morys was, it seems, lord of the manor there: we saw his brass again, it is really a very pretty one. The harvest being now out of the barn, we saw the corbels that support the wall pieces: they are certainly not later than 1250, so the barn is much earlier than I thought. The building of the walls and buttresses is remarkably good and solid.

Thomas Hardy (1840–1928) *Hardy's Cottage at Higher Brockhampton, Dorset* DORSET COUNTY MUSEUM, DORCHESTER

It faces west, and round the back and sides
High beeches, bending, hang a veil of boughs,
And sweep against the roof. Wild honeysucks
Climb on the walls, and seem to sprout a wish
(If we may fancy wish of trees and plants)
To overtop the apple-trees hard by.

Red roses, lilacs, variegated box
Are there in plenty, and such hardy flowers
As flourish best untrained. Adjoining these
Are herbs and esculents; and farther still

A field; then cottages with trees, and last
The distant hills and sky.

Behind, the scene is wilder. Heath and furze
Are everything that seems to grow and thrive
Upon the uneven ground. A stunted thorn
Stands here and there, indeed; and from a pit
An oak uprises, springing from a seed
Dropped by some bird a hundred years ago.

From Thomas Hardy's 'Domicilium'

Cottages, Barns and Smaller Houses [55]

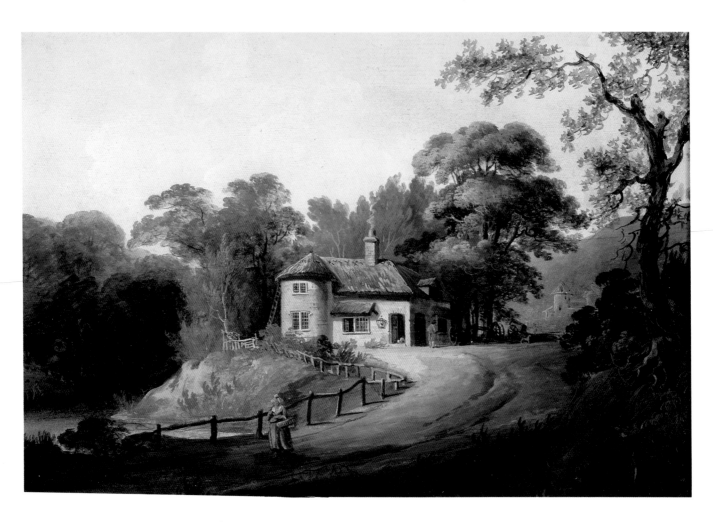

English, *c.*1798 *A Cottage at Atcham* ATTINGHAM PARK, SHROPSHIRE (Berwick Collection)

A cottage of a quiet colour, half concealed among trees, with its bit of garden, its pales and orchard, is one of the most tranquil and soothing of all rural objects, and as the sun strikes upon it and discovers a number of lively picturesque circumstances, one of the most cheerful.

 Uvedale Price,
 An Essay on the Picturesque, 1794

Before the 1790s few people looked at cottages in this way, least of all those condemned to live in what were mainly wretched hovels. And even a dedicated disciple of the Picturesque movement like the landscape gardener Humphry Repton was prepared, albeit reluctantly, to tear them down, if they were in the wrong place. That was the fate of the village of Atcham, which he felt intruded uncomfortably into the spacious new park he was designing at Attingham for the 2nd Lord Berwick. The old London–Shrewsbury road had already been re-routed outside the park, the boundary of which was announced by an imposing Neo-classical entrance screen and lodge gates, designed by his partner John Nash. At the same time the cottagers of Atcham were unceremoniously moved to the far side of the new road. The one compensation was the new village that Nash designed for them – determinedly 'quaint' thatched cottages grouped with careful informality around a new village green with its own pub, the Talbot. One would hardly guess from the set of seven small panels at Attingham which record Nash's designs that his cottages were brand new.

Joseph Horner *Blaise Hamlet* THE NATIONAL TRUST

The Atcham cottages were one of the first of several such schemes by Nash, but only tantalising fragments, such as a Gothic bay window, seem to have survived, if the project was ever completely carried through. Much more famous and, happily, still intact are the cottages at Blaise Hamlet, near Henbury in Gloucestershire.

A Quaker banker from Bristol, John Scandrett Harford, wanted to provide accommodation for retired workers on his estate. The traditional solution would have been a terrace of almshouses, bearing an inscription loudly proclaiming his philanthropy. In 1810–11 Nash came up with a more modest and original idea: ten detached cottages, loosely arranged around a green with its own sundial and well in a secluded woodland setting. Nash took immense trouble over the details, particularly the moulded brickwork of the tall chimneys. Although the cottages share the device of an encircling 'cat-slide' of thatch or stone slates projecting over the ground floor, no two are the same. The German traveller Hermann von Pückler-Muskau, who visited in 1828, called it 'the "beau idéal" of a village':

The gardens, divided by neat hedges, form a pretty garland of flowers and herbs around the whole village. What crowns the whole is that the inhabitants are all poor families, whom the generous proprietor allows to live in the houses rent-free. No more delightful or well-chosen spot could be found as a refuge for misfortune: its perfect seclusion and snugness breathe only peace and forgetfulness of the world.

The Blaise Hamlet pensioners were not to enjoy their peace for long. The spot was soon invaded by curious devotees of the Picturesque movement, to such an extent that the public had to be barred from Repton's landscaped woodland. As the frustrated Pückler-Muskau commented, paraphrasing Dante: 'di *entrare* lasciate ogni speranza [abandon hope *of* entering here]'. Blaise Hamlet has drawn those bitten by the dangerous bug of cottage life ever since.

Cottages, Barns and Smaller Houses [57]

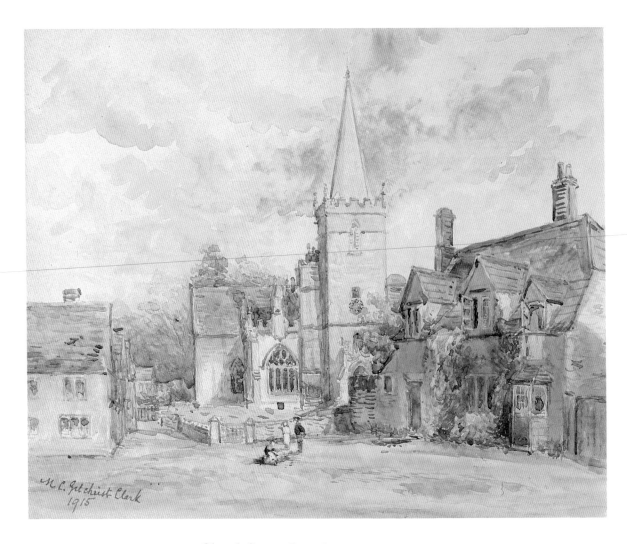

Matilda Gilchrist Clark (d.1927) *Church Street, Lacock*, 1915 LACOCK ABBEY, WILTSHIRE (Talbot Collection)

The year after Matilda Gilchrist Clark painted this view, her daughter – another Matilda – inherited the ancient village of Lacock, which she described in her memoirs, *My Life and Lacock Abbey*:

It consists of four streets forming a square. These streets are named High Street, East Street, Church Street and West Street. The three former are commonly called Top Street, Middle Street and Bottom Street, but West Street, for some reason, has no other name. In the space enclosed by the four streets are little yards and gardens, but there are no gardens, as a rule, in front of the houses. In fact, the whole construction is that of a small medieval town, rather than a village . . .

In medieval days there were handloom weavers in Lacock, working in wool and probably also in linen, and all the essential crafts would be represented; masons, carpenters, blacksmiths, leadworkers (as plumbers were then called), bakers, and butchers. I can remember all these trades being plied in the village, and there were three inns, and, half a mile away, a brewery. Manor Farm, with its dwelling house, barns and cowhouses, stood within the confines of the village, and altogether Lacock must always have been a self-supporting place.

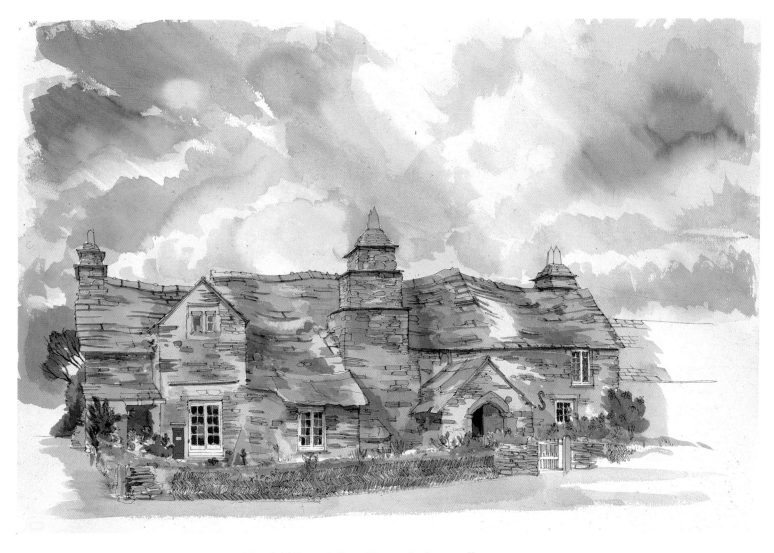

Alan Powers *The Old Post Office, Tintagel, Cornwall* THE NATIONAL TRUST

Before 1840 a letter of a single sheet cost a shilling for the first 300 miles and a penny for every additional 100 miles – an expensive business, if you lived in north Cornwall. Rowland Hill's Penny Post changed all that, and the growth of the postal system following his reforms encouraged the GPO to open a Letter Receiving Office in the fourteenth-century manor house at Tintagel in 1844.

The Tintagel Post Office did good business with the increasing number of visitors drawn by Tennyson and Matthew Arnold to the legendary birthplace of King Arthur and tomb of Tristram and Iseult. However, the very popular-ity of Tintagel threatened to sweep away the old village in a tide of new hotels and shops. In 1895 the Post Office itself was put on the market for redevelop-ment. A group of local artists, led by Catherine Johns, was determined to save this ancient building and organised a sale of prints after works by twelve well-known painters to raise the money. The campaign was successful and, after a careful restoration by the architect Detmar Blow, it was sold to the National Trust in 1903. The roof has recently required further attention, but its famously tipsy silhouette has been retained.

Cottages, Barns and Smaller Houses [59]

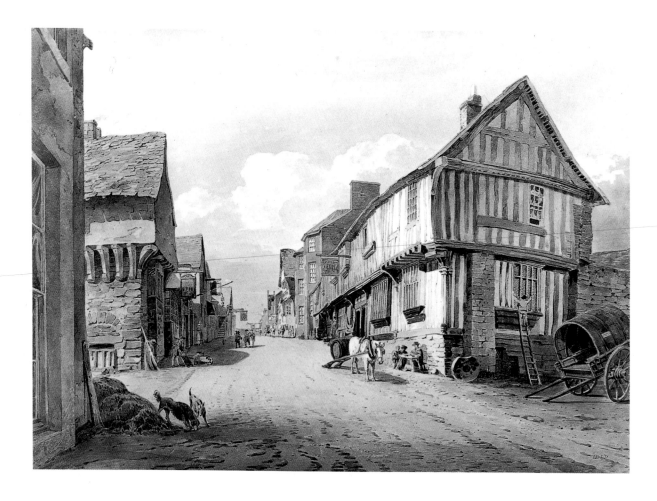

John Varley (1778–1842) *View up the High Street, Conway,* *c.*1802–3 VICTORIA AND ALBERT MUSEUM, LONDON

From an early age John Varley had set his heart on being a painter, but his father disapproved and sent him to work at a law stationers:

Young Varley had to be at the office at eight o'clock every morning, and the work of the day was very trying; yet such was his enthusiasm for art, and his desire to improve himself, that when daylight permitted he always had two hours' sketching in the morning before proceeding to his office, the carts and barrows in the streets, and the characteristic figures with which at that early hour they are peopled, forming subjects for his pencil.

After Varley's father died in 1791, his mother relented, and so, with his friend J.P. Neale, he 'sallied forth in search of the picturesque'. One of the favourite places to find picturesqueness at that time was North Wales, and in 1798 or 1799 he made the journey recommended in the guidebooks from Chirk via Capel Curig and Conway to Cader Idris. A second trip followed, around 1800–2, when he sketched the half-timbered buildings that lined Conway High Street. Considered 'quaint' even then, they have long since gone – all but Aberconwy House, the building on the left at the junction with Castle Street. This somehow survived, serving from 1850 to 1910 as a Temperance Hotel. One tantalisingly brief reminder of that period is a postcard of Aberconwy House dated 1907:

We are having a nice time. I went through this house yesterday. It is a boarding house. It would interest Master as it is so old. Love from Lily.

Henry George Moon (1857–1905)

The George Inn from Borough High Street, 1885

From *The Inns of Old Southwark*, 1888

Until 1750 every carrier bringing goods by road into the City of London from the South East had only one way of crossing the Thames – London Bridge. From the southern end of the bridge, on which the heads of executed felons were regularly displayed, stretched the Borough High Street of Southwark. Inns and alehouses once lined this vital artery of London trade, serving the needs of travellers and those attracted to Southwark by its numerous brothels and the Bankside theatres like the Globe and the Rose. At the Tabard Inn Chaucer's pilgrims spent the night before setting out for Canterbury. Charles Dickens's Mr Pickwick first met Sam Weller in the yard of the White Hart. All were swept away by the coming of the railways to Southwark in 1844 and the ceaseless redevelopment of London ever since – all but the George.

By 1885, when this engraving was made, the George was itself in a fairly forlorn state. The eighteenth-century open galleries, which are such a feature of the surviving fragment, had been boarded up on the north side, over the entrance to the inner courtyard. Five years later two sides of the courtyard were completely demolished by the Great Northern Railway Company to make more space for its waggons. However, the George found a stout defender in its manageress, Amelia Murray. She was more interested in preserving what was left of the historic inn than in making money, and from 1878 to 1903 she successfully prevented it being modernised. Her daughter Agnes ran the place in very much the same spirit for another 30 years, so that by 1937, when it was offered to the National Trust, it was one of the few seventeenth-century buildings left in Southwark. Never before had the Trust accepted a property 'on the chance of obtaining sufficient money to preserve it . . . They had no funds with which to buy it and indeed no funds with which to repair any structure.' The money was eventually found by granting a lease to the Stratford brewer Flower & Sons, and the George still survives, not as a historical relic, but as an agreeable place for a lunchtime pint.

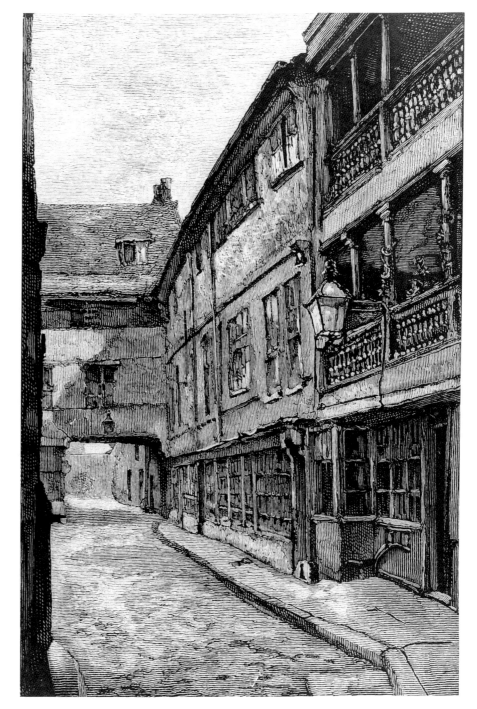

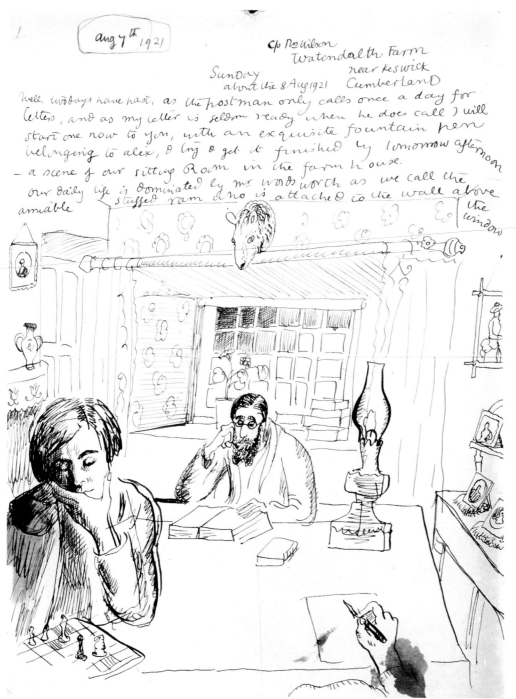

Dora Carrington (1893–1932)

Sketch of the back parlour,
Stepps End Farm, Watendlath, 1921

In August 1921 Lytton Strachey and some of
his Bloomsbury friends and relations spent a
summer holiday in the Lake District. They took
rooms with Mr and Mrs Wilson at Watendlath
(now Stepps End) Farm, near Keswick.
Carrington described and illustrated the scene
in a letter to Gerald Brenan, shortly to become
her lover:

Our daily life is dominated by Mr Wordsworth
as we call the amiable stuffed ram [sic] who is
attached to the wall above the window. Lytton
sits muffled in overcoats reading 'Family Life'
by C.F. Benson looking infinitely depressed,
Alix [Strachey] plays chess with an invisible
James [Strachey, her husband], who has crept
out of the picture. They take twenty minutes
over every move, and never speak, and I sit as
you see at the corner of the table. It is black
night outside and rains.

Carrington's husband Ralph Partridge arrived
shortly afterwards and when the rain stopped,
tried some fishing – without much luck.
Carrington herself set up her easel outside
opposite Stepps End Farm:

I sat and drew a white cottage and a barn . . .
sitting on a little hill until it grew too cold . . .
The trees are so marvellously solid, like trees
in some old Titian pictures, and the houses
such wonderful greys and whites, and then
the formation of the hills so varied.

[62] *Cottages, Barns and Smaller Houses*

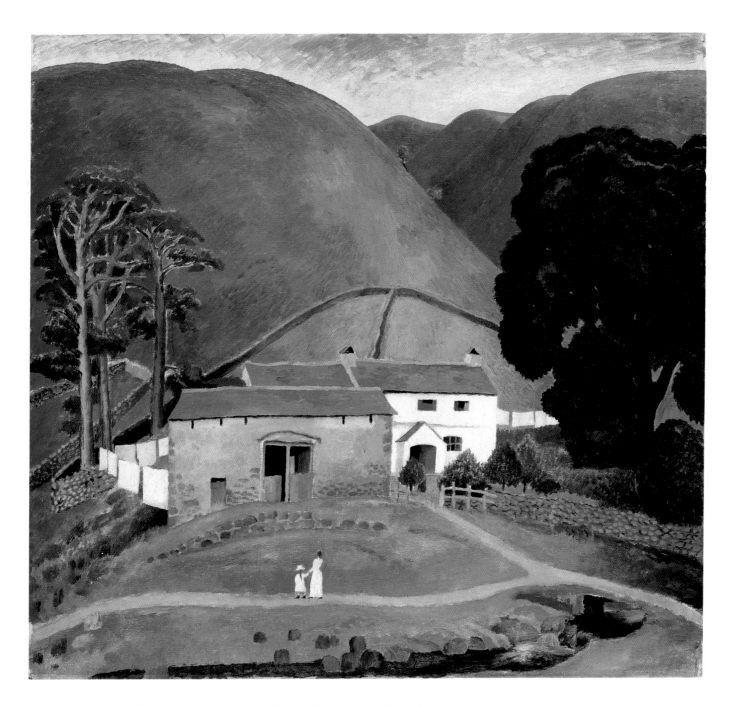

Dora Carrington (1893–1932) *Stepps End Farm, Watendlath*, 1921 TATE GALLERY, LONDON

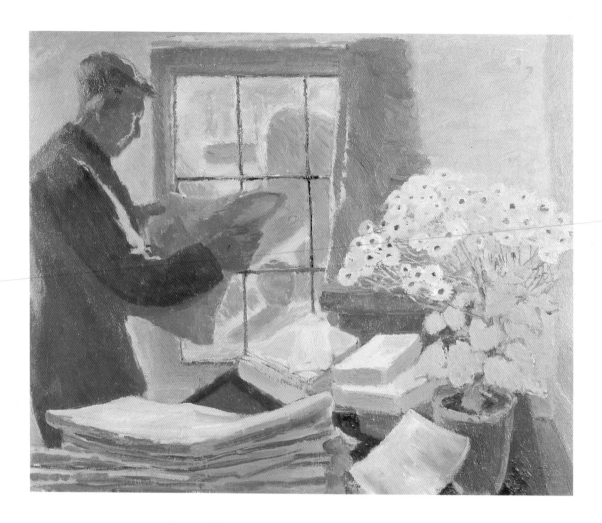

Trekkie Ritchie (b.1902) *Leonard Woolf at Monk's House*, *c*.1950 MONK'S HOUSE, EAST SUSSEX

In July 1919 Virginia and Leonard Woolf bought Monk's House in East Sussex:

The room at the White Hart was crowded. I looked at every face, & in particular at every coat & skirt, for signs of opulence, & was cheered to discover none. But then, I thought, getting L. into line, does *he* look as if he had £800 in his pocket? Some of the substantial farmers might well have their rolls of notes stuffed inside their stockings. Bidding began. Someone offered £300, "Not an offer", said the auctioneer, who was immediately opposed to us as a smiling courteous antagonist, "a beginning". The next bid was £400. Then they rose by fifties. Wycherley [who was bidding for the Woolfs] standing by us, silent and unmoved, added his advance. Six hundred was reached too quick for me. Little hesitations interposed themselves, but went down rather dismally fast. The auctioneer egged us on. I daresay there were six voices speaking, though after £600, 4 of them dropped out, & left only a Mr Tattersall competing with Mr Wycherley. We were allowed to bid in twenties; then tens; then fives; and still short of £700, so that our eventual victory seemed certain. Seven hundred reached, there was a pause; the auctioneer raised his hammer, very slowly; held it up a considerable time; urged & exhorted all the while it slowly sank towards the table. "Now Mr Tattershall, another bid from you – no more bidding once I've struck the table – ten pounds? five pounds? – no more? for the last time then – *dump*!" & down it came on the table, to our thanksgiving.

Robert Bates (b.1943)

Mr Straw's House, 1992

FOUNDATION FOR ART

In one episode of *Hancock's Half-hour* Tony Hancock offered 23 Railway Cuttings, East Cheam to the National Trust. 'The Trust take on a nineteenth-century suburban semi?' The idea was ridiculous, and he was sent away with a flea in his ear.

It is a measure of how much attitudes have changed that so few people were surprised when the Trust opened No.7 Blyth Grove in Worksop in Nottinghamshire to the public in 1993, and that it should have attracted so much interest. From the outside the solid, red-brick semi-detached house looks little different from the hundreds of thousands put up around the turn of the century, which still make sensible, attractive homes. The street itself has a curiously timeless quality. As an 'unadopted' road, it lacks the yellow lines, the signs and all the other more or less necessary intrusions demanded by modern planning legislation. However, the real difference lies inside and in the character of the family who lived here.

No.7 Blyth Grove was bought in 1923 by William Straw, a prosperous local grocer, for his wife Florence and their sons William and Walter. The family's tranquil life was suddenly shattered in 1932, when William senior collapsed and died whilst out gardening. The home became a shrine to his memory. Nothing was changed and after his widow died in 1939, their bedroom was simply left, with newspapers covering the bedspread and photos of their young sons on the dressing-table. Walter continued to run the family grocery business, and William pursued his antiquarian researches. Neither married nor felt any need to change the house they inherited. When things broke, they did not throw them away, they mended them, and the modern world was kept largely at bay. By 1990, when William, the last of the Straws, died, No.7 contained an extraordinarily rich record of middle-class provincial life 50 years ago that demanded preservation.

William James Linton (1812–97)

after Richard Doyle (1824–83)

The Scouring of the White Horse:
A Courtly Legend

From Thomas Hughes's
The Scouring of the White Horse, 1859

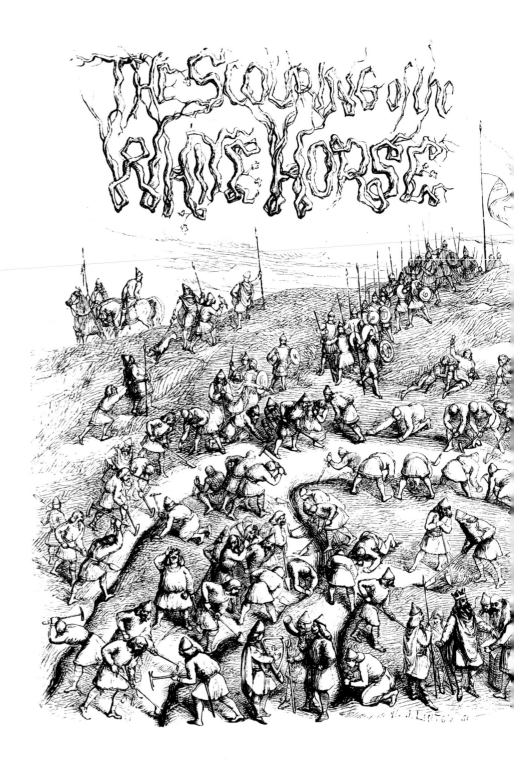

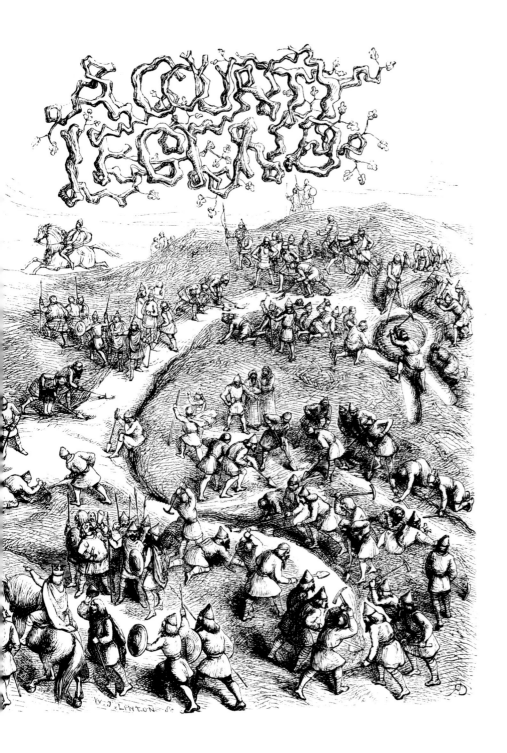

CHAPTER FIVE

ANTIQUITIES

Scouring of the White Horse at Uffington

The owld White Horse wants zettin to rights,
And the squire hev promised good cheer,
Zo we'll gee un a scrape to kip un in zhape,
And a'll last for many a year.

Anon.

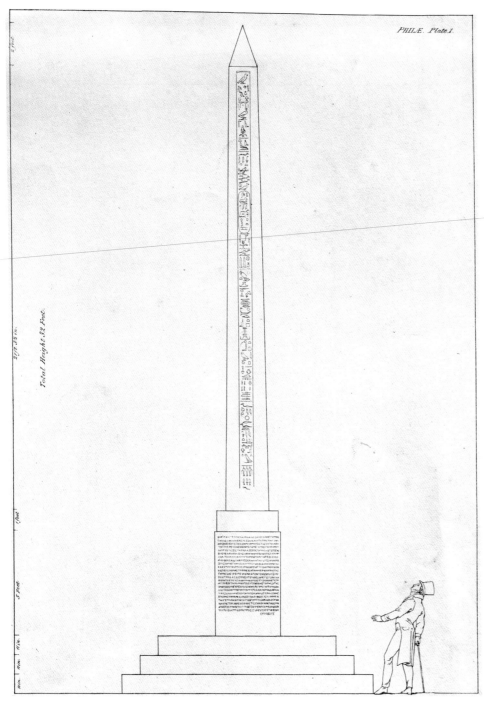

PHILÆ. Plate 1.

George Scharf (1788–1860)

*Geometrical Elevation of an Obelisk
from the Island of Philae*, 1821

KINGSTON LACY, DORSET (Bankes Collection)

On 13 September 1821 Harriet Arbuthnot noted in her diary:

Dined at the Chancellor of the Exchequer's [Nicholas Vansittart] and saw Mr. W[illiam John] Bankes, who told me that an Egyptian Obelisk was just arrived which he has brought from Philia, far above the cataracts, 1200 miles from Alexandria. He says it is a very curious one, being the only one the object of which is known. This one was raised to commemorate a remission of taxes in the reign of the great Ptolemy & Cleopatra. We proposed to Mr. Bankes to give this obelisk to Mr. Vansittart as an instructive lesson; but Van said *no*, that one to commemorate an *imposition* of taxes wd be more in his way.

Bankes duly re-erected the obelisk on the south lawn at his family home, Kingston Lacy in Dorset, where it remains to this day with other trophies of his Egyptian expeditions. These include beautiful drawings of the wall-paintings in the tomb of Rameses II at Abu Simbel, which had been made with considerable effort, as his companion Giovanni Finati described:

As for the interior, that, during all the time of our stay, was lighted every day, and almost all day long, with from twenty to fifty small wax candles, fixed upon clusters of palm branches, which were attached to long upright poles, and spreading like the arms of a chandelier, more than half way to the ceiling, enabled Mr. Bankes, and the other draughtsmen, to copy all the paintings in detail, as they stood, almost naked, upon their ladders.

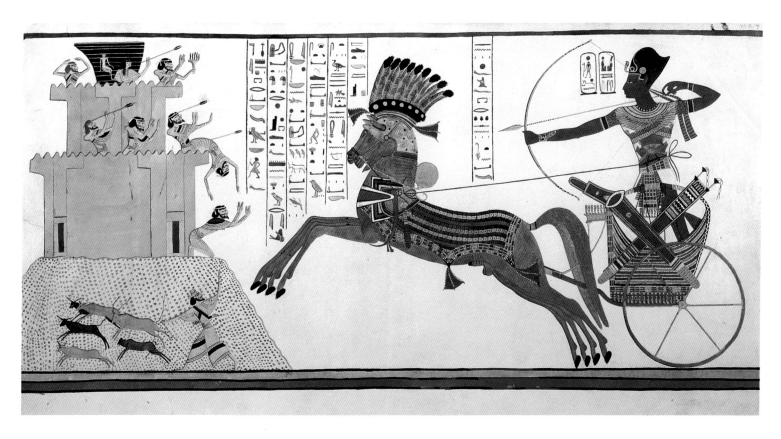

Louis Linant de Bellefonds (1799–1883) *King Rameses II in his Chariot* KINGSTON LACY, DORSET (Bankes Collection)

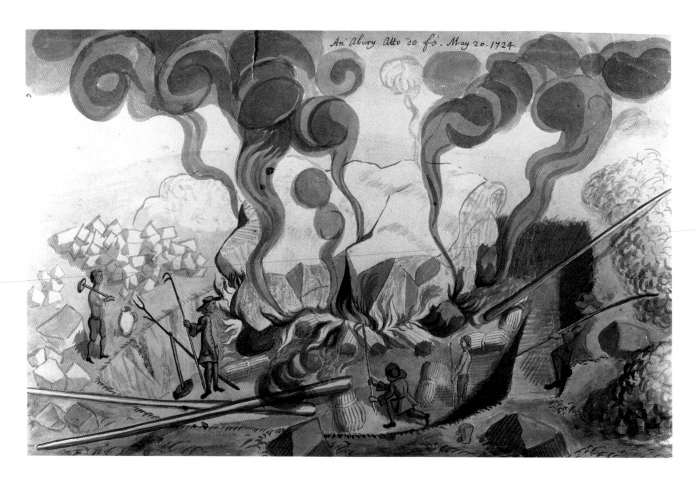

An Abury Atto de fe. May 20. 1724

William Stukeley (1687–1765) *Destroying a fallen stone at Avebury, Wiltshire*, 20 May 1724

BODLEIAN LIBRARY, OXFORD (Gough Map Collection)

It might seem hard to credit, but before William Stukeley arrived in 1719, almost no one had shown any interest in the complex of Early Bronze Age standing stones, ditches and ramparts that cover several square miles in and around Avebury. John Aubrey had come on the stones by chance in 1649 while out hunting and been impressed, thinking, rightly, that they 'exceed Stonehenge as a cathedral doth a parish church', but he was a lone voice. Indeed Stukeley was horrified to discover that the remains were being systematically demolished to provide building stone for the village of Avebury:

The barbarous massacre of a stone here with leavers and hammers, sledges and fires, is as terrible a sight as a Spanish Atto de fe. The vast cave they dig around it, the hollow under the stone like a glasshouse furnace or baker's oven, the

huge chasms made through the body of the stone, the straw, the faggots, the smoak, the prongs, and squallor of the fellows looks like a knot of devils grilling the soul of a sinner.

He was powerless to stop the 'massacre', but he could at least record the site with measured drawings and plans, against the day 'when the Country finds an advantage in preserving its poor reliques'. And he concluded, 'Future times may hence be able to ascertain its purport, when this sort of learning will be more cultivated.' As Stukeley predicted, scholarship has advanced, and a more enlightened attitude to our prehistoric monuments now prevails. It is also a tribute to his foresight and thoroughness that our understanding of Avebury still owes much to a survey made over 250 years ago.

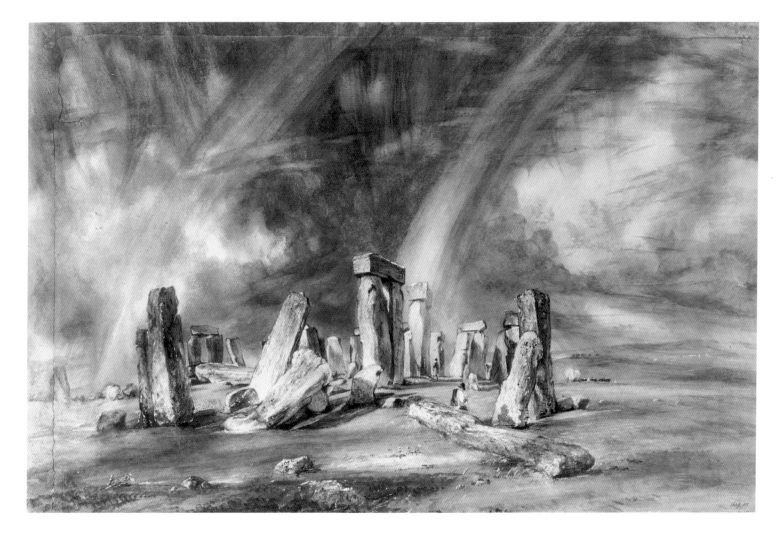

John Constable (1776–1837) *Stonehenge*, 1835 VICTORIA & ALBERT MUSEUM, LONDON

The mysterious Wiltshire monument of Stonehenge, standing remote on a bare and boundless heath, as much unconnected with the events of the past ages as it is with the uses of the present, carries you back beyond all historical records into the obscurity of a totally unknown period.

With these words Constable himself inscribed his last great watercolour. His wife Maria had been dead six years; his two eldest sons were away from home, and the other children were at boarding school in Hampstead. The house in Charlotte Street was empty. Increasingly in his final years he found himself looking back, not only to his boyhood in the Stour valley, as he had always done, but also to notebooks filled during his travels. He came on one little pencil sketch made in front of the sarsen stones on 15 July 1820, and worked it up from a matter-of-fact record into the final, highly charged image. The arcing double rainbow might suggest hope, but recent critics have seen in the black sky beyond some strange foreshadowing of the nuclear mushroom cloud. Certainly Constable seems to be meditating on the transience of human life – indeed of all life (note the hare scuttling through the left foreground) – in the face of a monument that has defied both time and explanation.

Antiquities [71]

Anonymous

Castlerigg Stones

From Thomas Pennant's
*A Tour in Scotland and Voyage
to the Hebrides; 1772, 1776*

On 23 May 1772 Thomas Pennant was on the road
from Thirlmere to Derwentwater in the Lake
District:

In the course of the descent, visit, under the guidance
of Doctor Brownrig (the first discoverer) a fine piece
of antiquity of that kind which is attributed to the
Druids. An arrangement of great stones tending to
an oval figure, is to be seen near the road side, about
a mile and a half from Keswick, on the summit of
a pretty broad and high hill, in an arable field called
Castle. The area is thirty-four yards from north to
south, and near thirty from east to west; but many
of the stones are fallen down, some inward, others
outward: according to the plan, they are at present
forty in number. At the north end, are two much
larger than the rest, standing five feet and a half
above the soil: between these may be supposed to
have been the principal entrance; opposite to it,
on the S. side, are others of nearly the same height;
and on the east is one near seven feet high. But what
distinguishes this from all other Druidical remains
of this nature, is a rectangular recess on the east side
of the area, formed of great stones, like those of the
oval. These structures are considered in general to
have been temples, or places of worship: the recess
here mentioned seems to have been allotted for the
Druids, the priests of the place, a sort of Holy of
Holies, where they met separated from the vulgar,
to perform their rites, their divinations, or to sit
in council, to determine on controversies, to
compromise all differences about limits of land,
or about inheritances, or for the trial of the greater
criminals; the Druids possessing both the office of
priest and judge. The cause that this recess was
placed on the east side, seems to arise from the
respect paid by the ancient natives of this isle to
that benificent luminary the sun, not originally
an idolatrous respect, but merely as a symbol of
the glorious all-seeing Being, its great Creator.

ANTIQUITIES.

William Bell Scott (1811–90)

The Building of the Roman Wall, 1857

WALLINGTON HALL, NORTHUMBERLAND

(Trevelyan Collection)

When in 1856 Walter and Pauline Trevelyan came to choose the scenes from Northumbrian history that would decorate their new Central Hall at Wallington, it was natural that they should ask William Bell Scott to include Hadrian's Wall. Although most of the Wall gently disappeared centuries ago, much still remains of what is undoubtedly the most impressive Roman monument in Britain. If one stands today on Cuddy Crags looking back at the wall as it snakes to the horizon, it is not all that difficult to imagine what life must have been like for a legionary on this most distant outpost of the Roman Empire almost two millennia ago.

Bell Scott shows the wall during construction, which began in AD122. A band of marauding Caledonians is attacking the stretch near Crag Lough, while the Romans hasten to defend themselves. Not all their British workers seem equally keen on the project. The lounger in the foreground is more interested in tending his boiling pot and playing dice (which he quickly hides under a hand from the approaching centurion). With typical Pre-Raphaelite precision Bell Scott made sure he got the details of the Romans' armour correct, and even borrowed a lump of the Wall itself to copy. The result has illustrated a hundred school textbooks since.

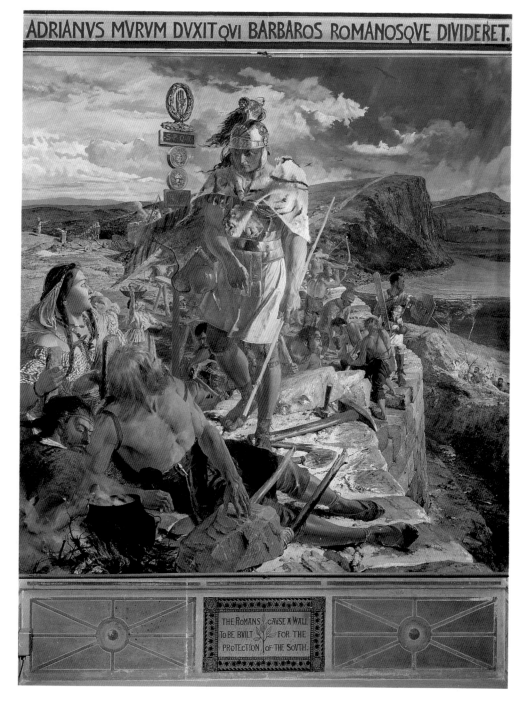

ADRIANVS MVRVM DVXIT QVI BARBAROS ROMANOSQVE DIVIDERET.

THE ROMANS CAVSE A WALL TO BE BVILT FOR THE PROTECTION OF THE SOVTH.

Samuel Hieronymous Grimm (1733–94) *The Interior of Bodiam*, 1784 BRITISH LIBRARY, LONDON

In 1788 the indefatigible traveller Lord Torrington tried to look round 'the noble remains of the square castle of Bodiham' in Sussex. It was 'a dark day with a howling wind unpleasant for tourists' and he had a frustrating time getting in:

This castle belongs to Sr Godfrey Webster, who has lock'd up the gate leading into the interior of the square; and from a narrowness of possession does not allow a key to any neighbour; tho, surely a proper inhabitant wou'd secure,

and preserve it, and get a livelyhood, (or at least much support,) from us, castle hunters. So I cou'd only walk around the little lake which washes the building; and adds much to the curiosity, and safety of the building.

Four years earlier the itinerant recorder of picturesque old buildings, S.H. Grimm, had had more luck. What he found would probably have annoyed Lord Torrington still further: the castle courtyard turned over to growing vegetables and a wooden shack propped against the ivy-clad walls of the old kitchen range.

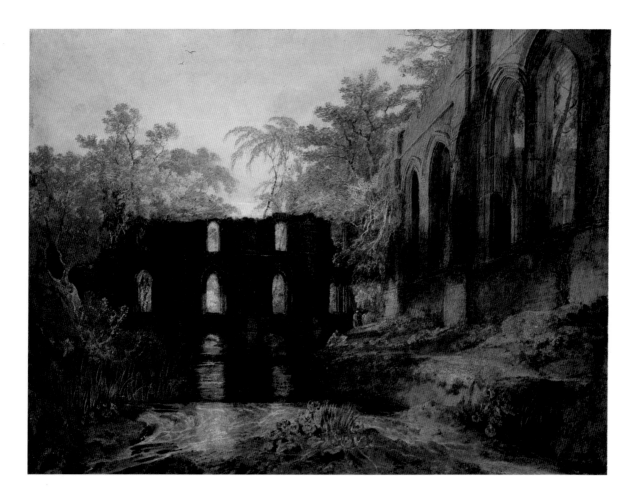

J.M.W. Turner (1775–1851) *The Dormitory and Transept of Fountains Abbey – Evening*, 1798 YORK CITY ART GALLERY

All ether soft'ning sober evening takes
Her wonted station on the middle air;
A thousand shadows at her beck –
In circle following circle, gathers round,
To close the face of things.

Turner chose these lines from James Thomson's *Seasons* to accompany the picture when he showed it at the Royal Academy in 1798. Seven years earlier the young Ann Radcliffe had published her Gothic novel *The Romance of the Forest*, which conjures up a similar scene of desolation:

He approached, and perceived the Gothic remains of an abbey: it stood on a kind of rude lawn, overshadowed by high and spreading trees, which seemed coeval with the building, and diffused a romantic gloom around. The greater part of the pile appeared to be sinking into ruins, and that which had withstood the ravages of time showed the remaining features of the fabric more awful in decay. The lofty battlements, thickly enwreathed with ivy, were half demolished, and become the residence of birds of prey. Huge fragments of the eastern tower, which was almost demolished, lay scattered amid the high grass, that waved slowly to the breeze . . . A Gothic gate, richly ornamented with fretwork, which opened into the main body of the edifice, but which was now obstructed with brushwood, remained entire. Above the vast and magnificent portal of this gate arose a window of the same order, whose pointed arches still exhibited fragments of stained glass, once the pride of monkish devotion.

Antiquities [75]

J.M.W. Turner (1775–1851) *Kilgarran Castle on the Twyvey, Hazy Sunrise, previous to a Sultry Day*, 1799

WORDSWORTH HOUSE, CUMBRIA (Lady Mildred Fitzgerald Collection)

Turner seems to have been encouraged to include Cilgerran (as it is now spelt) on his sketching tour of south Wales in 1798 by Richard Colt Hoare, who had been here five years earlier, as he described in his journal:

I was so delighted with this enchanting spot that I visited it three times, and visited it in every possible direction – it can only be seen to advantage by water.

Apart from establishing the present layout of the magnificent gardens at Stourhead in Wiltshire, Colt Hoare was a knowledgeable antiquarian and enthusiastic, if rather second-rate, topographical draughtsman. Like many of his generation, he had fallen in love with the sublime mountains of Switzerland, and found in the Welsh landscape the nearest British equivalent, buying a house at Bala from which to enjoy the scenery and his other great passion – fishing.

Samuel Buck (1696–1779) *The East Front of Tattershall Castle*, 1726 TATTERSHALL CASTLE, LINCOLNSHIRE

Three years after his visit to Bodiam, Lord Torrington was still 'castle hunting'. He arrived at Tattershall on 2 July 1791 in the rain:

Up at seven o'clock to a missling morn; and as soon as mine old hostess would descend, call'd for the bill. The rain being of no terror, I mounted Po: at 8 o'clock;

(G. to follow) and was soon at the village of Conisby, whose church is lightsome and well-built, with a bellfry under which is a thoroughfare. –

Crossing the little river, at times very deep, I came in ½ mile to Tattersall, a small market town, with a mean market-place. When I enter'd the Angel Inn, I felt happy to think I had gone to Tumby-Swan; and did not put up at this bad quarter. – A short ride before breakfast is just what I like, to enjoy the meal, and forward the day.

G. soon came in; and when breakfasted I took him with me to view the castle, the most perfect, the grandest piece of brick work in the kingdom. The ditch around is yet fenced by a wall, but all

the outer buildings are pull'd down; except a part of a porters lodge and an old stable. A poor family dwell in one angle; up which staircase with an excellent grooved banister, we mounted to the top; and half around the battlements, whence is an unbounded prospect: the walls are 15 feet thick; the cross beams, and the iron work, of the windows are left; but what is most to be admired are 3 antique stone chimney-pieces, laden with armorial bearings of the families above mention'd; which should be *taken care of*.

Carl Laubin (b.1947) *A Capriccio of National Trust Buildings*, 1993 FOUNDATION FOR ART

CHAPTER SIX

COUNTRY HOUSES

Comfortably padded lunatic asylums.

Virginia Woolf
on English country houses

Joseph Nash (1808–78)

The Clifton Maybank front at Montacute

From *Mansions of England in the Olden Time*, 1841

As a young boy Henry James used to lie on the carpet in the front parlour of his parents' New York home, poring over the illustrations in the 'tall entrancing folios' of Joseph Nash's *Mansions of England in the Olden Time*. From this childhood fascination grew his love affair with the English and 'the well-appointed, well-administered, well-filled country house' – 'a compendious illustration of their social genius and their manners'.

One of Henry James's favourites was Montacute, the Somerset mansion built from golden Ham Hill stone for Sir Edward Phelips in the 1590s: 'so perfect, with its grey personality, its old-world gardens, its accumulation of expressions, of tone'. Nash's romantic re-creation of Elizabethan Montacute matches James's reverie exactly, but, alas, is a chronological impossibility. The Clifton Maybank frontispiece actually comes from another Elizabethan home, near Yeovil, with which the Phelipses had a family connection, and was not added to the west front of Montacute until the 1780s – a piece of revivalism remarkably sensitive for the period.

Page after C. Pack *Blickling Hall*, 1778 From *History and Antiquities of the County of Norfolk*, iii, 1781

Visiting country houses, and then recording one's reactions, has a long history. This is Letitia Beauchamp-Proctor's account of her day at Blickling Hall in Norfolk in 1772, six years before this view was engraved. Neither the house nor its owners seem to have impressed her particularly:

In the morning, about ten we left Aylsham, and proceeded to Lord Buckinghamshire's, which was not more than two miles distant. We were afraid of being too soon, but on sending in our names, were admitted. We found they had breakfasted, and my lord's horses stood at the door, though the servant told us he was gone out. We saw no other traces of her ladyship than two or three work bags, and a tambour. I believe we drove her from room to room, but that we could not help. We saw only the old part of the house, over which a very dirty house-maid, with a duster in her hand, conducted us. The new wing is not finished, but, after all, I think there is nothing worth seeing in the house, except the library. No pictures, and the furniture all very bad, and, what is tolerable, not all adapted to the home; at least in my opinion, for I should never look for chinese papers, washing beds, window curtains and chairs, in an old gothic mansion. From the house we drove round the park, which certainly is fine, and the water good, if it was not so near the house.

We went into a belvedere, which is built on rather a rising ground and commands a good prospect: Woolerton in particular looks well from it. There is a tea room intended, but it is not yet finished. My lord overtook us in our approach to it, made a thousand courtier-like speeches, but they were so little worth attending to, that they went in one ear and out 'tother. One thing, however, I could not help remarking: he said he was mortified beyond expression that he happened to be out when we came, and you know I have mentioned his horses being at the door when we went in. He might have spared his apologies to me, for I was much better pleased to survey his house by ourselves.

Country Houses [81]

W. Wallis (b.1796) after John Preston Neale (1771/80–1847) *Ham House, Surrey*, 1820

From J.P. Neale's *Views of the Seats of Noblemen and Gentlemen, in England, Wales, Scotland, and Ireland*, iv, 1821

Horace Walpole tries to visit his niece Charlotte, the new Countess of Dysart, at Ham House in 1770:

It delighted me and made me peevish. Close to the Thames, in the centre of all rich and verdant beauty, it is so blocked up and barricaded with walls, vast trees, and gates, that you think yourself an hundred miles off and an hundred years back. The old furniture is so magnificently ancient, dreary and decayed, that at every step one's spirits sink, and my passion for antiquity could not keep them up. Every minute I expected to see ghosts sweeping by; ghosts I would not give sixpence to see, Lauderdales, Talmachs, and Maitlands. There is an old brown gallery full of Vandycks and Lelys, charming miniatures, delightful Wouvermans, and Polenburghs, china, japan, bronzes, ivory cabinets, and silver dogs, pokers, bellows, etc., without end. One pair of bellows is of filigree. In this state of pomp and tatters my nephew intends it shall remain, and is so religious an observer of the venerable rites of his house, that because the gates never were opened by his father but once for the late Lord Granville, you are locked out and locked in, and after journeying all round the house as you do round an old French fortified town, you are at last admitted through the stableyard to creep along a dark passage by the housekeeper's room, and so by a back-door into the great hall.

Attributed to George Cuitt the Elder (1743–1818) *Kedleston from the North-West,* *c.*1780

KEDLESTON HALL, DERBYSHIRE (Scarsdale Collection)

Nathaniel Curzon, the builder of
Kedleston Hall, had very clear ideas
about what he wanted out of life:

Grant me ye Gods, a pleasant seat
In attick elegance made neat

Fine lawns, much wood, and water plenty
(Of deer, & herds, & flocks not scanty)
Laid out in such an uncurb'd taste
That nature may'nt be lost but grac'd
Within doors, rooms of fair extent
Enriched with decent ornament

Choice friends, rare books, sweet musick's strain
But little business: and no pain
Good meats, rich wine, that may give birth
To free but not ungracious mirth
A lovely mistress kind and fair
Whose gentle looks disperse all care.

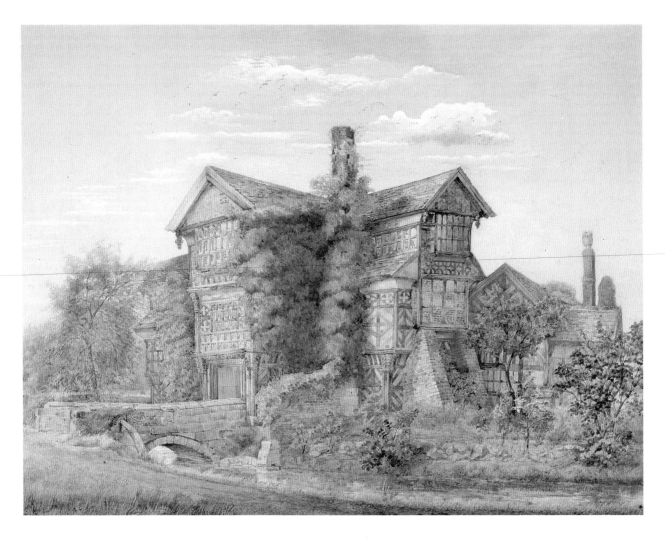

George Theaker *Little Moreton Hall, Cheshire*, *c*.1886 LITTLE MORETON HALL, CHESHIRE

Artists had been coming to draw the romantic half-timbered gables of Little Moreton Hall for over fifty years when James West approached the narrow bridge across the moat in 1847. The whole property was in a sorry state, the garden choked with weeds and ivy engulfing the chimneystacks. Only the block to the left of the Great Hall (where the shop and tea-room are now) was still inhabited, and from here emerged a groom who showed him over to the Chapel:

He led me across the courtyard to a door way, which I had thought was an entrance to the coal cellar, and sure enough there was a coal cellar, for what had once been the ante-chapel, was converted into a depot for coals and rubbish.

Despite the obvious decay and neglect, West was moved by the ancient building and pleased that he had been able to look around it alone:

No gossiping Cicerone had interfered with my wanderings. I had groped and stumbled into every available corner disturbing much ancient dust and alarming many venerable spiders.

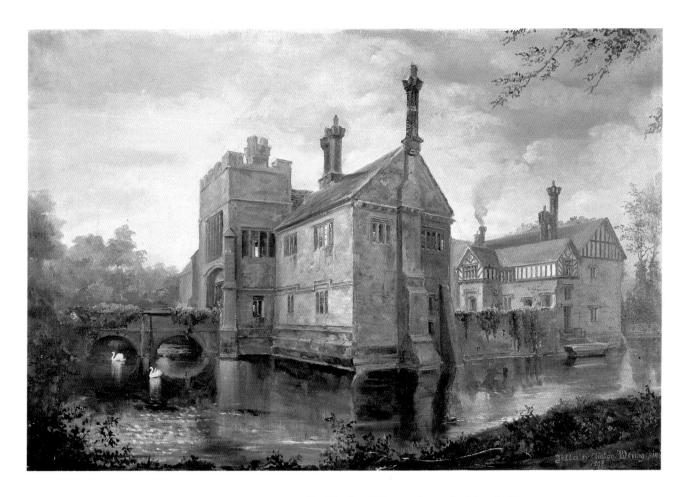

Rebecca Dulcibella Dering (d.1923) *Baddesley Clinton from the North-East*, 1898

BADDESLEY CLINTON, WARWICKSHIRE (Ferrers Collection)

Ancient moated manor houses have a romance all their own. When there are white swans gliding across the water as well, even the rising damp can be forgiven.

Baddesley Clinton takes part of its name from the Clinton family who excavated the moat in the thirteenth century. The Bromes built the house in the fifteenth century, and their successors, the Catholic Ferrers family, and most notably Henry ('the Antiquary') in the 1580s, filled it with sombre panelling and armorial glass.

The Ferrerses clung on to Baddesley through thick and thin, but by 1867, when the squire, Marmion Edward Ferrers, married Rebecca Dulcibella Orpen, the estate was deep in debt. Their financial predicament was eased by Rebecca's aunt, the romantic novelist Lady Chatterton, and her husband, Edward Dering, who came to live with the Ferrerses at Baddesley in the 1870s. However, there was more to this very Victorian arrangement than meets the eye. For Dering had once hoped to marry Rebecca. When he had asked Lady Chatterton's permission to court her niece, she had thought he was proposing to *her*, and Dering had been too much of a gentleman to disappoint her. The story has a happy ending: 30 years later, after both Lady Chatterton and Ferrers had died, the couple were finally married.

Rebecca was a talented amateur artist specialising in country house views, who painted a series devoted to Baddesley and its romantically gloomy interiors, which still hang in the house.

Attributed to Paul Sandby (1731–1809) *The Ruins of Cliveden, Buckinghamshire* PRIVATE COLLECTION

Disasters draw crowds and provoke speculation; the destruction of Cliveden by fire in 1795 was no exception. This is Caroline Lybbe Powys's diary entry for 29 July that year:

We had all a curiosity to see the ruins of the once magnificent Clifden House, so we set off, and mounted a very steep hill; the whole fabric, except one wing, a scene of ruin – the flight of stone steps all fallen in pieces; but what seem'd the most unaccountable was, that the hall, which had fell in, and was a mass of stone pillars and bricks all in pieces, but two deal folding-doors not the least hurt, looking as if just fresh painted! They were the entrance into the inner hall; an archway over them had fallen in. Poor Lady Orkney was then residing in the remaining wing. It seems she was much affected by a will that was deposited in a place where the flames were too fierce for anyone to venture, tho' she tried herself, and a man offer'd to venture too. The contents were not known, as it was not to be opened till her second son came of age. The fire at Clifden was on May 20th. We din'd at Mrs. Freeman's at Henley Park that night, and about 9.30 the servants came and told us Windsor Castle was on fire. On returning to Fawley Rectory, we saw the roof fall in – a tremendous sight; but on reaching the rectory, from my dressing-room window I saw it could not be Windsor Castle. The fire was caused by the carelessness of a servant turning down a bed.

Montbard *The Fire at Lanhydrock in 1881* LANHYDROCK, CORNWALL (Clifden Collection)

The road to Manderley lay ahead. There was no moon. The sky above our heads was inky black. But the sky on the horizon was not dark at all. It was shot with crimson, like a splash of blood. And the ashes blew towards us with the salt wind from the sea.

Daphne du Maurier, *Rebecca*, 1938

In Britain the greatest enemy of the country house, after the taxman, has always been fire.

Eleven miles up the wooded valley of the River Fowey from Daphne du Maurier's home at Menabilly stands Lanhydrock, the seventeenth-century seat of the Robartes family. On 4 April 1881 a chimney in the Lanhydrock kitchen caught light. A strong wind fanned the flames, which rapidly spread towards the Gallery in the north wing with its superb plasterwork barrel ceiling and library. The only way to save them was to create a firebreak by dynamiting the drawing-room next door. This drastic remedy worked, but the rest of the house was reduced to ashes. The human cost was even higher. Lady Robartes, aged 68, was caught in an upstairs room when the fire broke out and had to be rescued from a window by ladder. She died a few days later from the shock and her inconsolable husband followed her within a year. Undaunted by the loss of parents and home, their son Thomas set about rebuilding Lanhydrock as we see it today. He not only brought it up to Victorian standards of comfort and convenience, but took the understandable precaution of installing fireproof floors and water hydrants throughout.

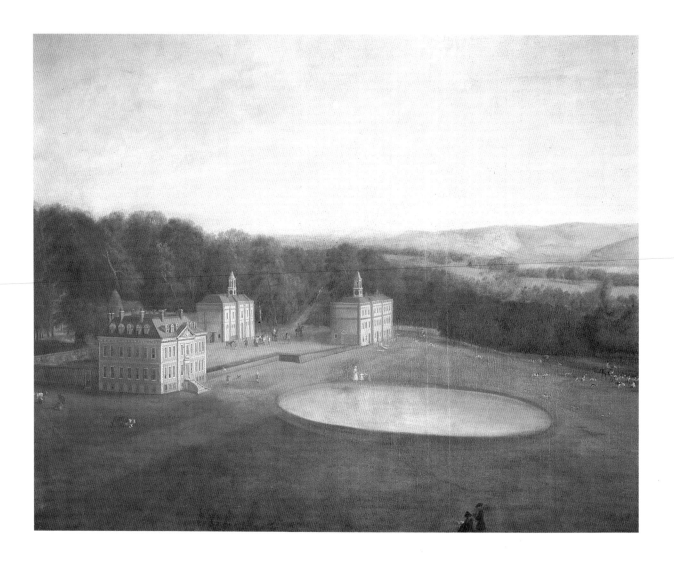

Peter Tillemans (c.1684–1734) *Uppark*, c.1728–30 UPPARK, WEST SUSSEX (Fetherstonhaugh Collection)

H.G. Wells spent his formative years in the 1880s at Uppark, where his mother was the housekeeper and his father the gardener. That world, which at Uppark had changed little since the 1770s, shaped his early outlook on life, as his heavily autobiographical novel, *Tono-Bungay*, makes clear:

Now the unavoidable suggestion of that wide park and that fair large house, dominating church, village, and the country-side, was that they represented the thing that mattered supremely in the world, and that all other things had significance only in relation to them. They represented the Gentry, the Quality, by and through and for whom the rest of the world, the farming folk and the labouring folk, the trades-people of Ashborough, and the upper servants and the lower servants and the servants of the estate, breathed and were permitted. And the Quality did it so quietly and thoroughly, the great house mingled so solidly and effectually with earth and sky, the contrast of its spacious hall and saloon and galleries, its airy housekeeper's room and warren of offices with the meagre dignities of the vicar, and the pinched and

Fitting the Venetian window. Looking over The Repton roof - Uppark: 26-8-92.

Leslie Worth (b. 1923) *Fitting the Venetian Window, Looking over the Repton Roof*, 1992 FOUNDATION FOR ART

stuffy rooms of even the post office people and the grocer, so enforced these suggestions, that it was only when I was a boy of thirteen or fourteen and some queer inherited strain of scepticism had set me doubting whether Mr Bartlett, the vicar, did really know with certainty all about God, that as a further and deeper step in doubting I began to question the final rightness of the gentlefolks, their primary necessity in the scheme of things. But once that scepticism had awakened it took me fast and far.

Wells went fast and far indeed, and the world changed with him. Yet the fabric of Uppark survived, thanks largely to the devoted restoration work of Margaret Meade-Fetherstonhaugh from the 1930s. Survived, that is, until August 1989, when the house was ravaged by fire. But just as Cliveden and Lanhydrock were rebuilt after similar disasters by earlier owners, so the National Trust has undertaken its most ambitious conservation programme ever at Uppark, in order to return the 'spacious hall' and 'airy housekeeper's room' to an appearance that Wells, stepping from his time machine, would recognise at once.

Country Houses [89]

Arthur Melville (1855–1904) *The Garden Front of Standen*, 1896 STANDEN, WEST SUSSEX (Beale Collection)

In 1896 Margaret and James Beale asked the Scottish watercolourist Arthur Melville down to paint their new house, which had been built only two years earlier by Philip Webb high on the Sussex Weald. Standen came to the Trust in 1973 very little changed, still with its Morris wallpapers and curtains. The Beales' grandchildren describe holiday visits to the house before the First World War:

On entering the front door we met the special Standen aroma of dried rose petals, eucalyptus and mimosa, which survives in memory today . . . Vast quantities of luggage were unloaded at the back door, and carried to our rooms in the nursery passage. We were transported to the drawing room to kiss Grand-

mother and then a rush up the back stairs to the nursery to make sure Dobbin [the family rocking horse] and the special toys were intact . . .

The garden was, of course, our great delight at every age. For the younger, the sand heap at the top of the sloping lawn was a never-ending joy. Sand was brought by one of the gardeners in a pony-cart from the rocky bank in the wood below the sandy lane. The nurses supervised from a row of chairs on the path above, having helped us collect our spades and buckets from the cupboard under the back stairs. This cupboard also contained the croquet set, bowls, tennis rackets and the little red trolley that took us with somewhat terrifying speed down the main lawn. Later the same lawn saw our first efforts on bicycles, often ending in a heap among the rhododendrons at the bottom.

Sir Edwin Lutyens (1869–1944) *Proposal perspective for Castle Drogo* CASTLE DROGO, DEVON (Drewe Collection)

A passion for genealogy can lead in many strange directions. Having made a fortune by the age of 33 from selling tea, in 1889 Julius Drew retired to the country to become a gentleman. He discovered that a distant ancestor, one Drogo (or Dru) de Teigne, had given his name to the parish of Drewsteignton in Devon. Here on a crag overlooking Dartmoor, he decided to build himself a castle – a proper castle with granite walls six feet thick – of the kind his Norman forebears might have conceived. He even changed his name to Drewe to increase its Norman resonance. His architect, Edwin Lutyens, had misgivings: 'Only I do wish he didn't want a castle but just a delicious lovable house with plenty of good large rooms in it,' he confided to his wife in August 1910. However, Drewe was not interested in lovability, and over the next twenty years Castle Drogo slowly took shape, with much discussion between architect and client. In the autumn of 1912 Drewe wrote to Lutyens:

May I ask *why* you have altered your opinion as to preparation of the granite facing? From the commencement you expressed your firm decision that only rough granite should be used. You told Jenkins that no tool marks were to be visible on any piece.

Lutyens replied:

The big, lumpy blocks are right for the lower courses but quite impossible to carry them up . . . it will mean a barbaric building worthy of a small municipal corporation. When a barbarian built a fortress he heaped up rocks and hid his women behind them. If those hard, wide stones are what you think I meant I am the Barbarian! I am very keen about your castle and must 'fight' you when I KNOW I am right.

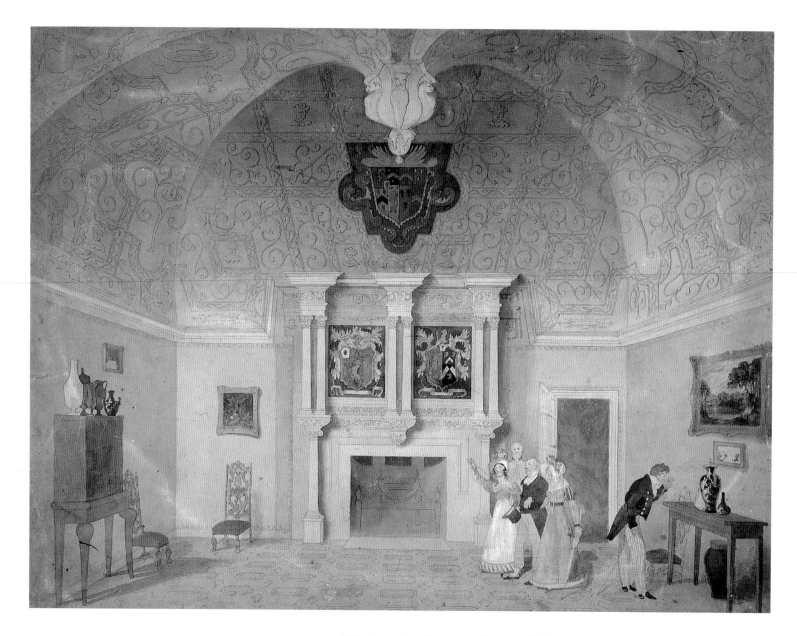

Edward Blore (1787–1879) *The Drawing Room at Canons Ashby*, *c.*1820

DEPARTMENT OF PRINTS AND DRAWINGS, BRITISH MUSEUM

CHAPTER SEVEN

INTERIORS

The whole party rose accordingly, and under Mrs. Rushworth's guidance were shewn through a number of rooms, all lofty, and many large, and amply furnished in the taste of fifty years back, with shining floors, solid mahogany, rich damask, marble, gilding and carving, each handsome in its way. Of pictures there were abundance, and some few good, but the larger part were family portraits, no longer any thing to any body but Mrs. Rushworth, who had been at great pains to learn all that the housekeeper could teach, and was now almost equally well qualified to shew the house.

Jane Austen, *Mansfield Park*, 1814

Nicholas Condy (*c.*1793–1857)

*The Court Dinner at Cotehele, Cornwall, c.*1840

PLYMOUTH CITY MUSEUM AND ART GALLERY

(Mount Edgcumbe Collection)

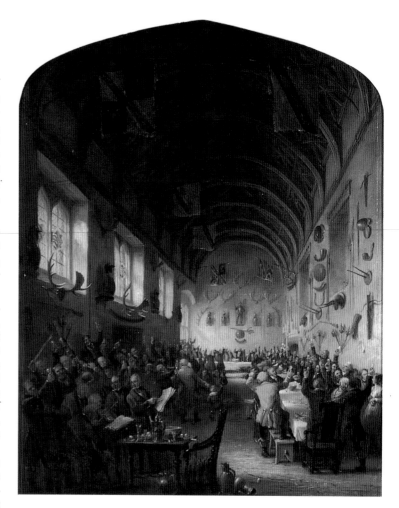

Nicholas Condy was brought up in Torpoint near Plymouth and only two miles from Antony. While serving in the army during the Napoleonic Wars, he discovered a talent for sketching. On his return he settled in Union Street in Plymouth, where he made a respectable living painting local views. To celebrate a visit by Queen Adelaide in the late 1830s, the 3rd Earl of Mount Edgcumbe commissioned Condy to paint a comprehensive series of watercolours of his ancient family seat, Cotehele, which lies fourteen miles north up the River Tamar. The album was such a success that around 1840 it was reproduced as lithographs, with an introduction by a conservation-minded local clergyman:

It is comparatively but a short time ago when mansion after mansion, possessing even the interest of Cotehele, was suffered to crumble into ruin or taken down to make way for modern erections. Happily that Vandal spirit is arrested, and there is now as eager a search for buildings that have the smallest pretensions to antiquity.

Although the head of the Edgcumbe family gave up living permanently at Cotehele in 1553 when Richard Edgcumbe built a new home at Mount Edgcumbe, the family refused to let it 'crumble into ruin'. It has traditionally been thought that they simply let the clock stop at Cotehele some time in the seventeenth century. However, John Cornforth has recently suggested that many of the rooms depicted so precisely by Condy (and little changed since) were in fact arranged in the 1730s by the antiquarian 1st Baron Edgcumbe to show to visitors, much as the Trust does historic interiors today. Despite this early 'fossilisation' of Cotehele, there were still plenty of opportunities for merry-making in the house, as Condy's painting of an uproarious Court Dinner in the Great Hall makes clear.

Around the time Condy was painting Cotehele, he was taken on by Joseph Pole-Carew of Antony to teach his only daughter Caroline to draw. Again, he painted a series of detailed interiors of the house, which Caroline copied as exercises. Unlike Cotehele, Antony has remained very much a family home, and it is interesting to see the way the rooms Condy painted have changed to meet domestic needs. In the Entrance Hall the chilly stone floor was replaced by wooden floorboards, and many of the landscapes and mythological pictures were sold to make way for the Shute portraits inherited in the 1920s, which now fill the staircase walls. The Victorians put warmth before light, and so in the mid-nineteenth century William Pole-Carew added a lumbering *porte-cochère* to the front of the house. This kept out the draughts, but unfortunately also made the Entrance Hall a much darker room than it was in Condy's time. However, many things, like the longcase clock and the portrait of the builder of the eighteenth-century house, Sir William Carew (the gentleman in blue over the fireplace), are still in the house, which remains one of the most attractive in Britain.

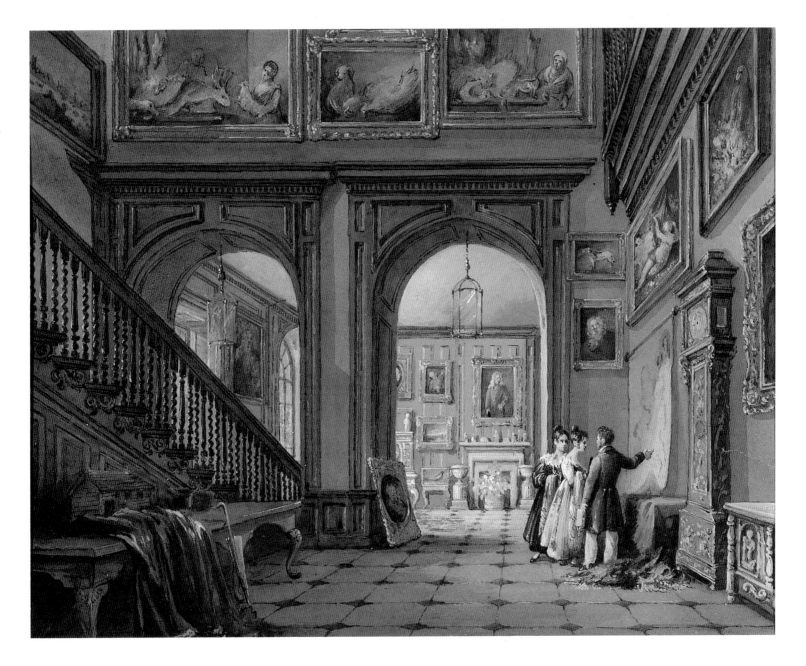

Nicholas Condy (*c.*1793–1857) *The Entrance Hall, Antony*, 1830s ANTONY HOUSE, CORNWALL (Carew Pole Collection)

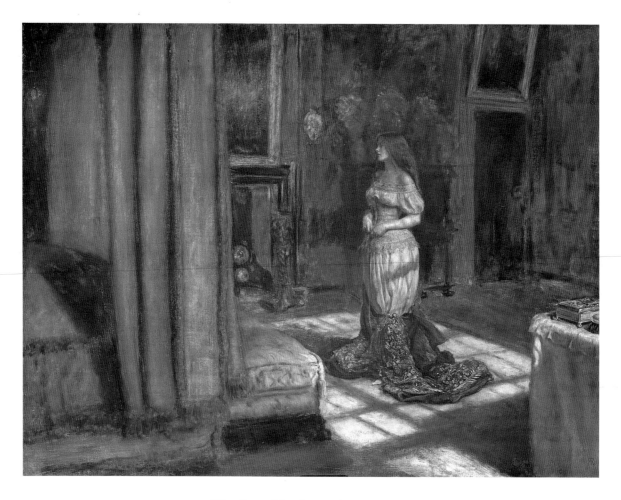

John Everett Millais (1829–96) *The Eve of St Agnes: Interior at Knole, near Sevenoaks*, 1862–3

HER MAJESTY QUEEN ELIZABETH THE QUEEN MOTHER

Anon his heart revives; her vespers done,
Of all its wreathèd pearls her hair she frees;
Unclasps her warmèd jewels one by one;
Loosens her fragrant bodice; by degrees
Her rich attire creeps rustling to her knees.

Millais set Keats's voyeuristic vision of Madeline undressing by moonlight in the King's Bedroom at Knole in Kent. It would be hard to think of a more atmospheric room in any English country house. James I is said to have slept here around 1609, and the extraordinarily rare late seventeenth-century state bed, embroidered with gold and silver thread, and the silver pier-glass, table and candlestands, glinting in the half-light, still give a potent flavour of that century.

Following the Pre-Raphaelite precept of Truth to Nature, Millais decided to paint the scene on the spot and at night. Unfortunately, he also chose to work in December. Knole has never been a warm house and Millais found conditions distinctly uncomfortable. As his long-suffering wife Effie, who posed for Madeline, recalled, 'Millais' fingers got numb with the cold'. However, after two days back in the studio, the artist had thawed out, and the picture was successfully completed.

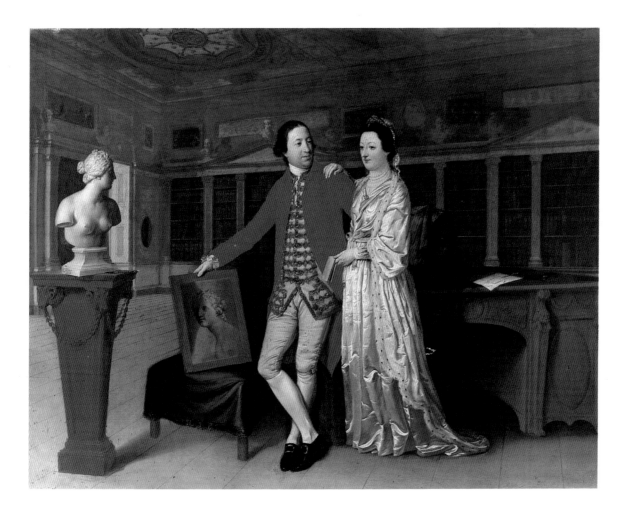

Anonymous, *c*.1770 *Sir Rowland Winn, 5th Bt, and his wife, Sabine Louise, in the Library at Nostell*

NOSTELL PRIORY, WEST YORKSHIRE (St Oswald Collection)

On 27 December 1766 Thomas Chippendale wrote from his London workshop in St Martin's Lane to Sir Rowland Winn in Yorkshire about the library table and clothes-press that were ready for delivery:

Your honour thought it was best to send them by water on account of the expense of land carriage. They are very good things and if the water should hurt them I should be very sorry but they may possibly come safe that way. Sometimes the damp of the ship affects the drawers and locks of good work which is made very close. These are some of the best work that can be done.

This was no empty boast, for the Nostell library table is generally considered the finest piece of mahogany furniture Chippendale ever made. Sir Rowland certainly seems to have taken his advice, as the table arrived safely afterwards, and has remained in the Library at Nostell ever since. Indeed so pleased was Sir Rowland that a few years later he had himself painted with his young French-Swiss wife, Sabine Louise, standing in front of it. Little has changed in the rest of the Library, which was the first room designed by Robert Adam for the 5th Baronet on his succession in 1765. The Winns' unknown painter cheated with the scale of the Library: it was never more than half this size.

George Hawkins (1819–52)

The Grand Staircase, 1846

PENRHYN CASTLE, GWYNEDD

(Douglas Pennant Collection)

In 1859 Queen Victoria and Prince Albert spent
a night at Penrhyn. This neo-Norman castle had
been built during the 1830s by George Dawkins-
Pennant out of the profits of his gigantic nearby
slate quarry. After dark, the castle and
particularly the Grand Staircase, with its
fearsome array of grotesque stone heads, is not a
place for the faint-hearted. Every effort was taken
to make the royal guests welcome, but even so
things went slightly awry, as Dawkins-Pennant's
granddaughter Adela recalled:

A man was specially had down from Miller's
the great lamp shop in London, to see after
the lighting of the house during the Royal visit,
instead of trusting to the services of the ordinary
'lamp man' of the House. This man deserted his
duties, to see the arrival of the Royal guests and
omitted to light the corkscrew staircase up to
the keep, so that when my mother took the Queen
to her room, she found the stairs in complete
darkness. My mother begged the Queen to wait
while she ran upstairs for a light, but on returning
to the head of the steps, she found the Queen had
laughingly groped her way up behind her in the
dark.

Martha Chute *The Stone Gallery*, 1850s THE VYNE, HAMPSHIRE (Chute Collection)

In September 1780 Caroline Lybbe Powys paid a visit to The Vyne. She found it 'indeed a noble old house' and was particularly taken with the Stone Gallery, which fills the entire ground floor of the west wing: 'they make a greenhouse of [it] in winter, and they say [it] has a most pleasing effect to walk thro' the oranges, myrtles, &c., ranged on each side.'

Seventy years later things were rather different. In 1837 Martha Buckworth had married William Wiggett, who had taken the name Chute on inheriting the house from his distant cousin, the 'Old Squire' William Chute, thirteen years before. Martha and William had ten children in rapid succession and the house was soon heaving with young Chutes. They discovered that the Stone Gallery made an ideal spot for indoor games of cricket, badminton and even football. The orange trees were banished, but the classical busts stayed put and somehow survived the effect of stray headers. The younger children could enjoy the rocking horse, the older wood-working on the lathe. And all the family could sit down to amateur theatricals beneath a proscenium arch painted with the family motto, *Fortune de Guerre* ('Fortune of War'), by Martha Chute, who also produced this delightfully unexpected view of English country life in the mid-nineteenth century.

Joseph Charles Barrow
(active 1789–1802)

*The Kitchen at Woolsthorpe
Manor*, 1797

ST ANDREWS UNIVERSITY
LIBRARY

By the late eighteenth century the
modest Lincolnshire farmhouse of
Woolsthorpe Manor was in a sad state
and its owner, Edmund Turnor, was
contemplating improvements. At that
time any other building of similar
architectural status would have been
modernised without record, but this
was already celebrated as the
birthplace, on Christmas Day 1642,
of perhaps the greatest mind Britain
has ever produced. Isaac Newton,
the founder of modern mathematics,
physics, optics and astronomy, spent
his first twelve years here. After
Cambridge had been struck by the
plague in 1665, he returned for an
astoundingly productive eighteen
months, when he was, as he put it,
'in the prime of my age for invention'.
During that period he discovered
differential calculus and the laws
governing the movements of the
planets, and conducted his famous
experiment to diffract light through
a prism.

So Turnor called in J.C. Barrow,
who drew a series of views of the inside
of the house in 1797, including this
glimpse into what was known, probably
justly, as 'the dirty kitchen'. It
occupied a thatched lean-to at the back
of the house, which was swept away by
Turnor's renovations. Eighteenth-
century views of such humble interiors
are extraordinarily rare, and the
connection with Newton makes this
drawing all the more precious.

Beatrix Potter (1866–1943)

Samuel Whiskers on the Stairs

From *The Tale of Samuel Whiskers*, 1908

Beatrix Potter dedicated *The Tale of Samuel Whiskers* to her pet white rat Sammy, 'The intelligent pink-eyed Representative of a Persecuted (but Irrepressible) Race. An affectionate little Friend, and most accomplished thief.' Her feelings about rats had not always been so charitable. When in 1905 she bought the seventeenth-century Lakeland farmhouse at Hill Top in Sawrey which became her home, she soon discovered that it was infested with rats. She wrote to Millie Warne the following year:

The rats have come back in great force, two big ones were trapped in the shed here, beside turning out a nest of eight baby rats in the cucumber frame opposite the door. They are getting at the corn at the farm. Mrs Cannon calmly announced that she should get four or five cats! Imagine my feelings; but I daresay they will live in the outbuildings.

Beatrix Potter's battle with the rats inspired *The Tale of Samuel Whiskers* and gives it an air of real menace. The story is set very largely inside Hill Top, and visitors today will have no difficulty recognising the staircase up which Samuel Whiskers is carrying the rolling pin to make a roly-poly pudding of Tom Kitten. The royalties from the 'little books' enabled Beatrix Potter to buy more land in the Lake District, which she bequeathed to the National Trust. On her marriage to William Heelis in 1913, she moved across the road to Castle Cottage, leaving Hill Top to be preserved as a shrine to Samuel Whiskers and his brethren.

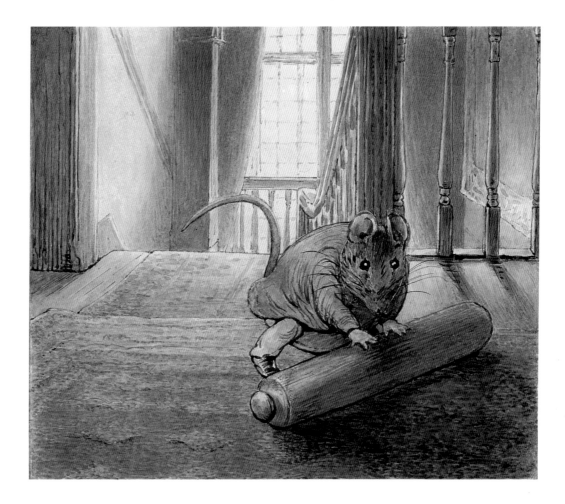

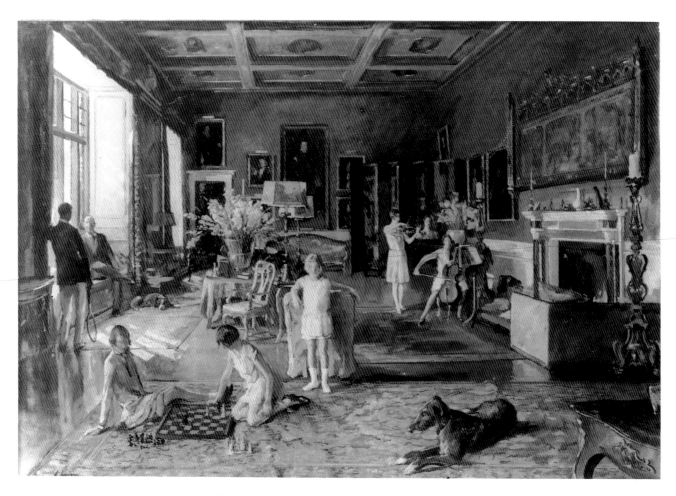

John Lavery (1856–1941) *The Howard de Walden Family in the Saloon at Chirk* PRIVATE COLLECTION

In 1911 the Howard de Waldens took on the lease of Chirk, a border castle in Flintshire (now Clwyd) which had been in continuous occupation since it was built in the 1290s. Within Chirk's forbidding walls, they enjoyed a comfortable family life, which they asked John Lavery to record. Margherita, Lady Howard de Walden describes the result in her autobiography, *Pages from my Life*:

The sun is shining in on to a Chinese rug and the enormous glass bowl of gladioli; one of the Coromandel screens shows behind the grand piano where Bronwen is playing the viola, Elizabeth the 'cello and my head is seen at the piano. A Flemish tapestry above the fireplace looks down on Gaenor and Pip sprawled on the floor over their chess-board, with Pip's big dog beside them.

Little Rosemary, in a yellow frock, leans against an armchair watching. And on the window-seat, framed by the dark red Spanish curtains, Tommy [Lord Howard de Walden] sits with Dick the bull terrier, at his feet, talking to John who is holding a tennis-racket and has his back to the room . . .

The funny part of the story was that as I walked through each mid-morning, after coping with the usual bunch of duties, I would see another figure added to the picture probably sitting on the sofa (one of the guests or my mother who was staying with us). John Lavery would say, 'Well, she sat there and so I thought that she wanted to be put in.' 'Yes,' said I, 'she did and does, but we do not want anyone else in that picture other than our two selves and our children.' But each day the same phenomenon was repeated! And he had the extra trouble of painting our 'picture-crashing' friends out again!

Ernö Goldfinger (1902–87) *Interior Perspective of 2 Willow Road, Hampstead, London*, 1978

2 WILLOW ROAD, LONDON (Goldfinger Collection)

'I could make lots more money if I designed neo-Tudor or Georgian abominations, but I won't,' the architect Ernö Goldfinger told a *Daily Sketch* reporter in 1937. He had been trained at the Ecole des Beaux-Arts in Paris by Auguste Perret, who believed that modern materials like reinforced concrete could express the fundamental proportions of the Classical orders without resort to superficial pastiche. Goldfinger himself said, 'I want to be remembered as a Classical architect.' When he brought his practice to Britain in 1934, few people were willing to see him in this light. His proposal in 1937 to build a terrace of three new houses looking out on to Hampstead Heath provoked an early example of outraged nimbyism from local residents. Goldfinger responded:

I think the opposition to these houses is based on a misapprehension. They are designed in a modern adaptation of the eighteenth century style, and are far more in keeping with the beautiful Downshire Hill houses round the corner than their neighbours in Willow Road . . . As for the objection that the houses are rectangular, only the Eskimos and Zulus build anything but rectangular houses.

Goldfinger's arguments won the day. The houses were built and No.2 Willow Road became his home, where he lived happily with his wife, the painter Ursula Blackwell, for the rest of his life, surrounded by furniture and fittings he had designed so well that they never needed to be changed. It survives today as a remarkably complete testament to a way of life that now seems almost as distant as the eighteenth-century Classical buildings which inspired it.

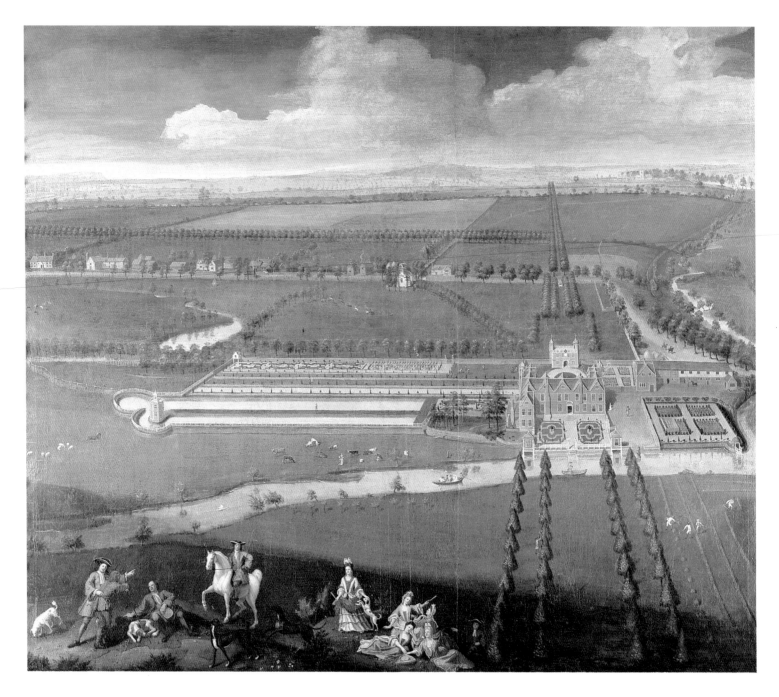

English, 1696 *View of Charlecote Park* CHARLECOTE PARK, WARWICKSHIRE (Fairfax-Lucy Collection)

CHAPTER EIGHT

GARDENS AND PARKS

Is there a shrub which, ere its verdures blow,
Asks all the suns that beam upon the Po?
Is there a flowret whose vermilion hue
Can only catch its beauty in Peru?
Is there a portal, colonnade or dome,
The pride of Naples, or the boast of Rome?
We raise it here, in storms of wind and hail,
On the bleak bosom of a sunless vale;
Careless alike of climate, soil and place,
The cast of nature, and the smiles of grace.

From James Cawthorn's
Of Taste, An Essay, 1771

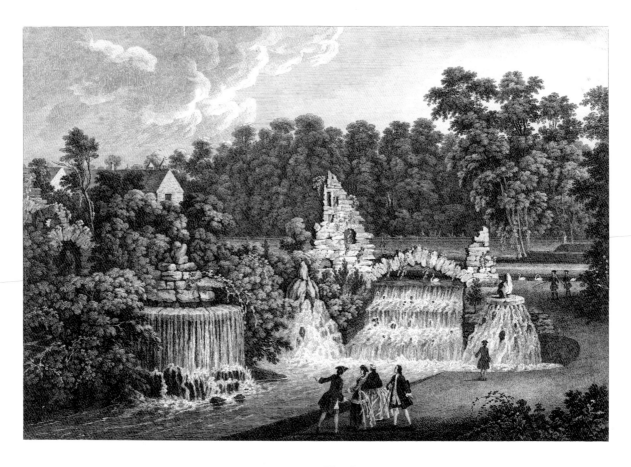

Francis Vivarès (1709–80) after Thomas Smith (d.1769) *The Cascade at Belton House, Lincolnshire*, 1749

BELTON HOUSE, LINCOLNSHIRE (Brownlow Collection)

John, Viscount Tyrconnel was that easiest target of ridicule – the self-important, but totally unsuccessful politician. George II dismissed him as 'a puppy that never votes twice together on the same side'. The letter-writer Mrs Delany, whom he wooed unsuccessfully in the 1730s, said, 'He had the character, very justly, of being silly, and I would not tie myself to such a character for an empire.'

There was, however, another side to the man. Tyrconnel was a knowledgeable collector of Old Master paintings, and patron of poets, sculptors and painters. He also spent freely on new plasterwork and tapestries to embellish Belton, the Lincolnshire

house he had inherited in 1721 from his uncle, who had built it a generation before. Tyrconnel later turned to improving the grounds. In May 1742 he diverted the River Witham, which was to the west of the house, to create a picturesque cascade. Spanning it was a carefully dilapidated Gothick folly, trailing fronds of ivy. The effect was completed by clever planting of trees and shrubs, which also helped to screen out William Stanton's stable block on the left. Never one to indulge in false (or true) modesty, Tyrconnel described the result in a letter to his nephew and heir, John Cust, in April 1745:

Belton never so Green and Pleasant; ye ponds and canal overflowing full, a grand Rustick arch finished with vast Rough Stones over ye Cascade of ye River, and two Huge Artificial Rocks on each side, Design'd and executed, as I think, in a taste superior to anything that I have seen, either at Lord Gainsborough's or Lord Cobham's.

After Lord Tyrconnel's death, his Gothick ruin decayed in earnest, but the cascade was restored around 1816 for the 1st Earl Brownlow in a more 'natural' style, so that today it hardly seems like the work of man.

Balthazar Nebot (active 1730–62) *View of the Cascade from the Water Garden, c.1760* PRIVATE COLLECTION

In September 1744 Philip Yorke, later 2nd Earl of Hardwicke, spent six hours riding around John Aislabie's magnificent garden at Studley Royal in Yorkshire:

The natural beauties of this place are superior to anything of the kind I ever saw, and improved with great taste both by the late and present owner. The extent of the whole is 710 acres, of which about 150 are reckoned into the garden, and the river Scheld [Skell], which runs through the ground, covers (as they told us) 23 of them. It is impossible from a single survey, however well conducted, to conceive oneself or give a stranger an adequate idea of Studley. Imagine rocks covered with wood, sometimes perpendicularly steep and craggy, at others descending in slopes to beautiful lawns and parterres, water thrown in 20 different shapes – a canal, a basin, a lake, a purling stream, now gliding gently through the plain, now foaming and tumbling in a cascade down 8 or 10 steps. In one place it is finely tuned through the middle arch of a rough stone bridge. The buildings are elegant and well suited to the ground they stand upon. The temple of Venus is at the head of a canal in the midst of a thick wood; that of Hercules on another spot not less delightful. A Gothic tower overlooks the park and gardens from the summit of a rock . . . You have besides several agreeable views of Ripon, the adjacent country, and Fountain's Abbey; and what seems almost peculiar to Studley is that the same object, taken at a different point of view, is surprisingly diversified and has all the grace of novelty.

Gardens and Parks [107]

Nicholas Dall (active 1756–76) *A View of Shugborough and the Park from the East, c.1768*

SHUGBOROUGH, STAFFORDSHIRE (Lichfield Collection)

In 1762 James 'Athenian' Stuart and Nicholas Revett published the first volume of their eagerly awaited *Antiquities of Athens*, which was based on the careful measured drawings of Classical Greek buildings they had made seven years before. Among the subscribers to the book was Thomas Anson, who was taken with the idea of re-creating these monuments in his park at Shugborough, and had just inherited the money to pay for it from his brother, Admiral Lord Anson.

Nicholas Dall's view, painted about six years later, records the result. Looking from left to right, we can see: the Triumphal Arch, which was based on the so-called Arch of Hadrian in Athens and was adapted by Anson to serve as a memorial to his brother; the Tower of the Winds, a copy of the Horologium of Andronikos Cyrrhestes, which was later converted into a dairy; and the Lanthorn of Demosthenes, again based on an Athenian model, the

Choragic Monument of Lysicrates. The pagoda belongs to the slightly earlier, chinoiserie phase in the development of the park, which recalls Admiral Anson's visit to Canton in 1743. The pagoda was going up in 1752, and so predates William Chambers's famous Kew pagoda by almost a decade, but, alas, it seems to have been swept away when the River Sow flooded the park later in the century. However, the smaller Chinese House (not shown by Dall) has survived and was celebrated in verses by Anna Seward, 'the Swan of Lichfield', written around 1760:

> Here mayst thou oft regale in Leric Bower
> Secure of Mandarins' despotic power . . .
> Safe from their servile yoke their arts command
> And Grecian domes erect in Freedom's Land.

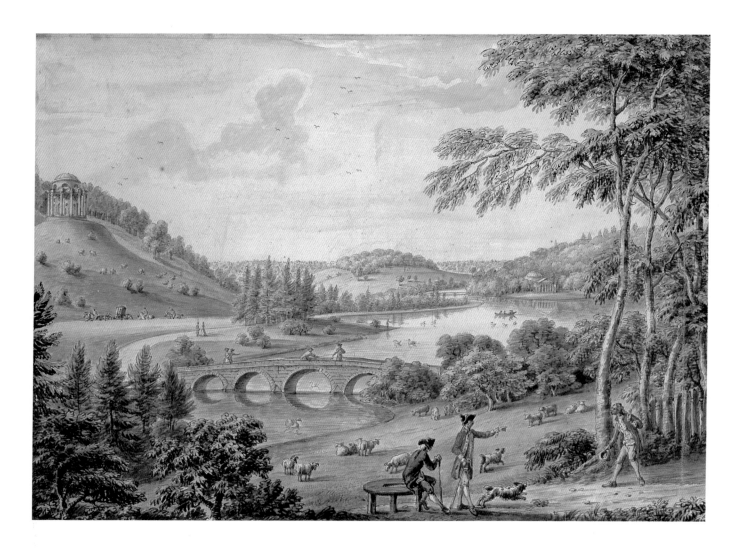

Coplestone Warre Bampfylde (1719–91) *A View of the Garden at Stourhead, Wiltshire, with the Temple of Apollo,*
the Palladian Bridge and the Pantheon, 1775 STOURHEAD, WILTSHIRE (Hoare Collection)

In 1765 the poet and historian Joseph Spence described a walk round Henry Hoare's famous picturesque garden to the Earl of Lincoln:

You . . . [walk along the side of the Lake to] the Temple of Apollo; taken partly from the Temple at Tivoli, & partly from a Temple to the Sun at Balbeck. There are 12 Corinthian Columns; and Niches for Eleven Statues: and the 12 Signs of the Zodiac are to be over these statues & the door. The Door exactly faces the Palladian Bridge; & from it you take in all the great Beauties of the place. It is to be lighted from the top of the Dome. Guido's Aurora, enlarged by the Seasons following the Chariot of Apollo, & Night flying from before her, is to be painted round the inside walls by Mr Hoar. When you sit deep within the Temple, you wou'd think it was built close by the Lake, & when you walk round the Latter below, you are almost continually entertained by the Reflection of it, in the water.

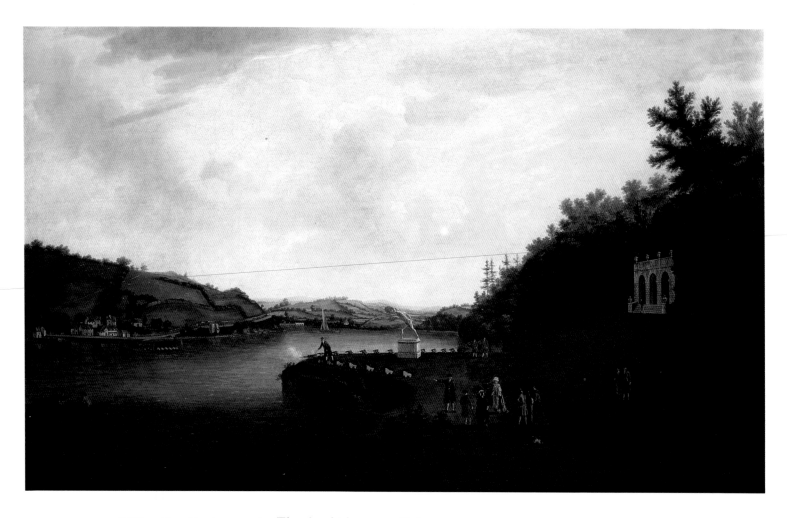

William Tomkins (1732–92) *The Amphitheatre at Saltram*, 1770 SALTRAM, DEVON (Morley Collection)

In the summer of 1789 George III and Queen Charlotte toured the West Country. The King had only recently recovered from his first bout of 'madness' and in France the Bastille had fallen to an enraged mob days before. Nevertheless the tour was a great success. 'Arches of flowers were erected for the Royal Family to pass under at almost every town, with various loyal devices, expressive of their satisfaction in this circuit,' wrote Fanny Burney, who was a member of the Royal party, but disliked the fuss: 'We had to make our way through a crowd of starers the most tremendous.'

In August they stayed at Saltram house in Devon, 'one of the most magnificent in the kingdom.' Guns fired from the battery on the banks of the Plym, horns sounded, to salute the arrival of the Royal party in a scene not dissimilar to that painted by William Tomkins nineteen years before. But the King really wanted peace and quiet, preferring to walk down through Saltram Wood to the Amphitheatre by the river. So did Fanny Burney:

This morning the Royals were all at a grand naval review. I spent the time very serenely in my favourite wood, which abounds in seats of all sorts . . . The wood here is truly enchanting; the paths on the slant down to the water resemble those of sweet Norbury Park . . . Today was devoted to general quiet; and I spent all I could of it in my sweet wood, reading the 'Art of Contentment', a delightful old treatise, by the author of 'The Whole Duty of Man', which I have found in the Saltram Library.

John Claude Nattes (*c.*1765–1822) *View from the South Portico looking towards the Grenville Column, Stowe,*
Buckinghamshire, 1805 BUCKINGHAMSHIRE COUNTY MUSEUM, AYLESBURY

It is just after 12 o'clock on Thursday, 22 August 1805. The setting is the giant South Portico of Stowe: 'quite an orange grove, being filled with orange trees in the finest blossom and green House plants', according to Betsey Fremantle, who was staying in the house for the visit of the Prince of Wales, which had drawn 10,000 people to the Marquess of Buckingham's famous gardens the previous Friday. In one corner Betsey's sister Harriet is talking to Lord Buckingham's daughter, Lady Mary Grenville. They have much to talk over, as Mary is being courted by the Catholic James Arundell, and her brother, Lord Temple, does not approve. Harriet describes what followed in her diary:

After dinner Lord Temple had a long conversation with Lady Mary and she cried. In the course of the evening she begged me to tell Mr. Arundell to meet us in the Portico tomorrow morning. I found a favourable opportunity to speak to him. He looked surprised.
FRIDAY, 23RD. I did not sleep well and got up very early. Went in Lady Mary's room before nine and found her dressing. Lady B[uckingham] came in, in her night cap, looking half distracted and telling us she saw Arundell walking by himself and could not make out what rendered him so dull. We did not say much, but as soon as she was ready we got out and found Mr. Arundell in the library. He followed us to the Portico and we went down the steps which made him retreat, he however soon came to us, and the conversation which passed between them was most proper. Lady M. intreated him never to come back again, and explained matters so well, that he promised to go to morrow without fail. I think it luck there is no love between, as an explanation would have cost them very dear, instead of which they freely spoke their sentiments, and nothing not friendship ever subsisted between them. I was awkwardly situated and did not speak one word. We looked very dull at breakfast.

But love was not to be denied so easily: six years later Lady Mary and Mr Arundell were married.

J.M.W. Turner (1775–1851)

The Lake, Petworth: Sunset,
Fighting Bucks, c.1829

PETWORTH HOUSE, WEST SUSSEX

(On loan from Tate Gallery, London)

'The very animals at Petworth seemed happier than in any other spot on earth,' wrote Benjamin Robert Haydon, one of the many artists welcomed to Petworth by the 3rd Earl of Egremont. Indeed an earlier version of this painting (now in the Tate Gallery) shows the 3rd Earl walking down to the lake, with his nine dogs scampering after him. His rather ramshackle household also included Elizabeth Ayliffe, their six children (all born out of wedlock), numerous servants ('most of them very advanced in years and tottered, and comical in their looks', according to Thomas Creevey, who visited in 1828), and for long periods in the late 1820s and 1830s, J.M.W. Turner. The artist was given his own studio in a room over the chapel, which the 3rd Earl alone was allowed to enter, and then only after two sharp knocks on the door.

The view from the Carved Room, where this picture was probably created and where it was intended to hang under the Grinling Gibbons carvings, has changed hardly at all since Turner painted it around 1829. The cricketers have drawn stumps, but the 3rd Earl's favourite black sheep still graze and his deer lock horns under the windows, silhouetted against the sun as it sets over 'Capability' Brown's great serpentine lake.

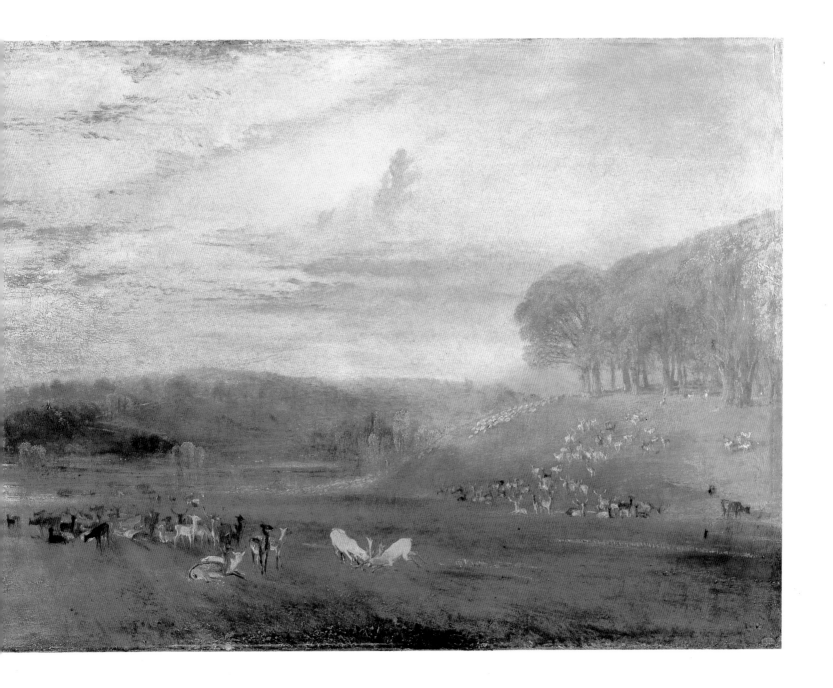

Anonymous, early nineteenth-century *View of Powis Castle* POWIS CASTLE, POWYS (Powis Collection)

The venerable Powys Castle is going fast into decay. The buildings are in a state of dilapidation; the gardens and grounds are neglected and the pride and ornament of the park is being removed for the sake of the timber. What the hand of time is doing for the one, the hand of avarice is doing for the other; so that at no distant period the beauty and magnificence of Powys will be no more.

Fortunately, the gloomy predictions of the Rev. John Evans, who visited Powis around 1798, proved groundless. Catherine Sinclair passed this way thirty years later:

From Ellesmere we made our excursion through Oswestry to Powis Castle. . . . It seems like the realization of a romance to enter there, as greater traces of antiquity remain visible in all directions, than I ever saw in any inhabited house before. . . . From the terrace behind Powis Castle is displayed a valley which must surely excel even the celebrated plain of Damascus. The broad Severn winds its serpentine course through an undulating park, bounded by richly wooded hills, and dotted over with massy beeches and gigantic oaks, beneath which reposed large herds of deer. Close to the house is a flight of steps, carved in the solid rock, descending into a garden, laid out in shelving terraces, divided by noble yew hedges, and gaudy with flowers.

Thomas Robins (1716–70) *The Palladian Bridge, Prior Park, Bath* COURTAULD INSTITUTE OF ART

Francis Kilvert describes a visit to Prior Park in January 1874:

In the afternoon Mr Gwatkin, Annie and I walked through Widcombe by the ivied Church under Crow Hill and up the private road to Prior Park. We went boldly in at the Lodge Gates and made our way unchallenged past the long damp dreary ranges of ugly buildings, half barrack, half jail, till we turned the last wing and came round to the garden front and the great portico looking over Bath. The shrubbery through which we passed was tangled, wild, and overgrown with long neglect. Upon the great stone balustrades of the wide terrace stairs sat four peacocks, one a white bird, a huge white swan lumbered waddling along a grass-grown gravel path on his way down to the lakes in the hollow of the park, and two ecclesiastics in cassocks and birettas tramped up and down the grand terrace-walk smoking, laughing and spitting right and left. Every now and then the strange musical note of a swan sounded like a trumpet from the bushes. Splendid terraces with balustrades of carved stone and broad shallow flights of stone steps descended from the great portico to the lawns and gardens and the distant lakes gleaming misty in the wooded hollow . . .

Prior Park has been a magnificent place, but Ichabod, Ichabod, the glory is departed and the days of Ralph Allen are no more. It would take a large fortune to keep the place in repair and beauty. At present the great stones of the noble flight of terrace steps are sadly broken and shattered and the gardens, lawns and shrubberies seem to be going to ruin and decay.

Gardens and Parks [115]

Ramsay Richard Reinagle (1775–1862) *Cattle and Deer in Calke Park* CALKE ABBEY, DERBYSHIRE (Harpur-Crewe Collection)

When you pass through the lodge gates at Ticknall on the Derbyshire/Leicestershire border, you enter a private and ancient landscape. Like many medieval monks, the Augustinians chose a secluded spot when they founded their priory at Calke in the early twelfth century – an enclosed and wooded valley fed by a gentle stream. The famously reclusive Harpur family, owners of Calke from 1622,

only increased the atmosphere of secrecy that pervaded the place.

Among the ancient, stag-headed oaks at the heart of the park today are fragments of the woodland planted by the Augustinian monks seven centuries ago. They in turn form an unbroken link with the primeval 'wildwood' that once covered much of Britain. As a result, the park provides a rich habi-

tat for insects, and is one of the best places in the country to study beetles. The red and fallow deer painted by Reinagle have probably also been here since medieval times. All that is needed to complete the picture are the Highland cattle, which are said to have been introduced to the park in the 1770s by the 6th Baronet, Sir Harry Harpur, but were sold off by his descendants in 1886.

Anonymous *China: Garden Scene at Biddulph Grange* SALT LIBRARY, STAFFORD, STAFFORDSHIRE

From the 1871 sale catalogue

'China' lies at the heart of Biddulph, the Staffordshire garden created from 1842 by James and Maria Bateman and their friend, the painter E.W. Cooke. Edward Kemp, an influential gardening writer of the time, described the inspiration behind this garden in somewhat patronising terms:

The chief design of this singular piece of landscape, beyond the primary one of collecting together the numerous Chinese and Japanese hardy plants with which our gardens abound, appears to have been the representation of one of those eccentric and somewhat grotesque efforts of gardening art in which the Chinese are said to indulge, and some crude idea of which has no doubt been familiar to every one from childhood, in the old Willow-pattern dinner plate . . . With his puny fort or prospect-tower crowning one of his tiny hills, and his covered bridge and cosy pleasure house to decorate the pool on which a full-rigged junk rides securely at anchor, [the Chinaman] probably dreams that he has created a prodigy of art, and adds large dragon-shaped flower beds, and other equally harmonious details, to complete the scene.

Kemp was gradually won over, and for visitors today 'China' is usually the climax of their tour, the greatest in a series of surprises that make Biddulph among the most remarkable survivals from the great age of Victorian gardening.

Gardens and Parks [117]

Charles Paget Wade (1883–1956)

The Yew Alley, Snowshill Manor, c.1951

SNOWSHILL MANOR, GLOUCESTERSHIRE

(Wade Collection)

Charles Wade – architect, artist and collector of craftsmanship – arrived at Snowshill in 1919. The garden that greeted him was not a promising sight:

The old house . . . stood sad and desolate in the midst of a wilderness of chaos, the result of long years of neglect.

What is now the courtyard was a jungle of rampant nettles, with narrow tracks trodden to the various doors. Nettles covered the slope from the very walls of the house right down to the Kitchen Garden, strewn with old iron, bones, broken crocks and debris.

The only wall was that to the orchard on the south which follows the fall of the ground.

Springs had formed a treacherous swampy morass in what is now the lower garden; it had been the cattle yard.

But Wade quickly set to work with the help of the architect M.H. Baillie Scott, and has explained the principles governing his new garden:

First the house required a secure base to stand upon to lose the feeling it gave of being about to slide into the depths of the vale far below, so terraced levels and retaining walls were necessary.

A garden is an extension of the house, a series of outdoor rooms. The word garden means a garth, an enclosed space, and so the design was planned, a series of separate courts, sunny ones contrasting with shady ones. Courts for varying moods.

The Plan of the garden is much more important than the flowers in it. Walls, steps and alley ways give a permanent setting so it is pleasant and orderly in both winter and summer.

The contrast of the deep and sombre tone of Yew with the vivid green of lawn, changing in the evening to lights of gleaming gold between the long creeping shades.

Sir Edward Poynter (1836–1919) *A View of Bateman's, East Sussex, from the South-West*, 1913

BATEMAN'S, EAST SUSSEX (Kipling Collection)

Our England is a garden, and such gardens are not made
By singing:– 'Oh, how beautiful' and sitting in the shade,
While better men than we go out and start their working lives
At grubbing weeds from gravel paths with broken dinner-knives.
<div align="right">Kipling, 'The Glory of the Garden'</div>

The seventeenth-century sandstone manor house of Bateman's meant home and England in almost a mystical way to Rudyard Kipling, who settled here aged 37 in 1902. He was proud to have designed most of the garden himself. The double row of pleached limes was there when Kipling arrived but he laid out the flagged terrace which he christened 'the Quarter Deck', the semicircular wooden seat and encircling yew hedge (a very Arts and Crafts touch, found also at Ascott in Buckinghamshire and Wightwick Manor in the West Midlands), and the rectangular pond in which his young children could swim and sail model boats. (The initials 'F.I.P.' against the names in the Bateman's visitors' book meant 'Fell in Pond'.) In this watercolour, painted by Kipling's uncle, one of the family is feeding the goldfish from a safe distance.

However, this seemingly peaceful garden, the product of honest English toil, contained intimations of mortality. Kipling inscribed the sundial at the south end of the pond 'It is later than you think'. Fateful words: two years after this picture was painted, his beloved only son, John, died at the Battle of Loos, and the Bateman's idyll was shattered for ever.

Cherryl Fountain (b.1950) *The Spanish Garden, Mount Stewart, Co. Down,* 1988–90 FOUNDATION FOR ART

In 1922 Edith, Marchioness of Londonderry crossed Co. Down from her home at Mount Stewart to pay a visit to Sir John Ross's famous garden at Rostrevor:

After viewing a succession of marvellous shrubs I innocently remarked, 'I have never seen such shrubs before. It might be the gardens at Kew.' The old man stopped dead, and in a strained voice exclaimed: 'Dear Lady Londonderry, never mention Kew to me again. I can grow things here that Kew has never heard of!' And thus I learnt!

Lady Londonderry learnt so well from Rostrevor that Mount Stewart now has one of the great gardens of Europe. As she explained in 1938 in her auto-biography:

Irish gardens differ considerably from the ordinary conception of an English garden, in which one's thoughts move in the direction of herbaceous borders and rose gardens. In Ireland, owing to the mild and humid atmosphere, similar to Devon and Cornwall, plants of all descriptions flourish. Enthusiasts in early days encouraged expeditions to distant parts of the globe in search of rare plants and shrubs, and during the last twenty to thirty years, or even more, a rich store of material has been brought home, and trees and shrubs from all parts of the world have been included in what these experts term their 'collection'. In such a garden you will see well-grown, lovely specimens of half-hardy flowering shrubs, and large trees flourishing. They are grouped in situations to suit the individual specimens, rather than in massed colour formation, and from quite a different gardening orientation they are full of interest and very beautiful.

Lawrence Johnston (1871–1958)

Flower-piece

HIDCOTE MANOR, GLOUCESTERSHIRE

On 6 July 1943 James Lees-Milne visited the garden at Hidcote which Lawrence Johnston, its creator and painter, was considering giving to the National Trust:

The garden is not only beautiful but remarkable in that it is full of surprises. You are constantly led from one scene to another, into long vistas and little enclosures, which seem infinite. Moreover the total area of this garden does not cover many acres. Surely the twentieth century has produced some remarkable gardens on a small scale. This one is also full of rare plants brought from the most outlandish places in India and Asia. When my father and Laurie Johnston were absorbed in talk I was tremendously impressed by their profound knowledge of a subject which is closed to me. It was like hearing two people speaking fluently a language of which I was totally ignorant.

Samuel van Hoogstraten (1627–78)

A View down a Corridor, 1662

DYRHAM PARK, GLOUCESTERSHIRE

(Blathwayt Collection)

CHAPTER NINE

ANIMALS

But above all things, I do most admire his piece of
perspective especially, he opening me the closed door
and there I saw that there is nothing but only a plain
picture hung upon the wall.

Samuel Pepys, 26 January 1663

George Stubbs (1724–1806)

Hambletonian, Rubbing Down, 1800

MOUNT STEWART, CO. DOWN

(Londonderry Collection)

In March 1799 the *Sporting Magazine* reported 'the greatest concourse of people that ever was seen at Newmarket. The company not only occupied every bed to be procured in that place, but Cambridge and every town and village within twelve or fifteen miles was also thronged with visitors.' What had brought all these people together was the match between Sir Henry Vane-Tempest's great stallion Hambletonian and Joseph Cookson's Diamond. A prize of 3,000 guineas was riding on the result, and side-bets were said to have amounted to 20–30,000 guineas. The race was over four miles, and as they entered the last four furlongs both horses were neck and neck, until, according to the *Sporting Magazine*, Hambletonian 'by an extraordinary stride or two, some say the very last stride, won the match by a little more than *half a neck*.'

To commemorate this famous victory, Vane-Tempest commissioned Stubbs to paint a life-size portrait of Hambletonian being rubbed down after the race. Although the result is one of the greatest equine pictures ever painted, Vane-Tempest seems to have been unhappy with it; certainly Stubbs had to take him to court to get paid. It is not difficult to see why Vane-Tempest might have been disconcerted. As the *Sporting Magazine* admitted, 'Both horses were much cut with the whip, and severely goaded with the spur, but particularly Hambletonian; he was shockingly goaded.' Stubbs paints an animal in the last stages of exhaustion. Happily, Hambletonian recovered to race, and win, again, and enjoyed a quiet retirement at Vane-Tempest's country seat, Wynyard Park, Co. Durham. The picture passed to Vane-Tempest's daughter, who married the 3rd Marquess of Londonderry, and that is how it comes to hang on the stairs in that family's Irish home.

William Hayes (active 1773–99)

Study of a Bird from 'Mr Child's Menagery'
at Osterley Park, Middlesex

PENRHYN CASTLE, GWYNEDD

(Douglas Pennant Collection)

In 1763 the banker Robert Child inherited Osterley Park, the family's villa to the west of London, on the sudden death of his brother, Francis. He carried on Robert Adam's ambitious scheme to remodel the house and built an aviary in the northeast corner of the park for his wife Sarah's collection of exotic birds. Agneta Yorke described how it looked in 1772:

The Menagerie is the prettiest place I ever saw, 'tis an absolute retreat, & fill'd with all sorts of curious and scarce Birds and Fowles, among the rest 2 numidian Cranes that follow like Dogs, and a pair of Chinese teal that have only been seen in England before upon the India [wall]paper.

Sarah Child wanted a permanent record of the menagerie and so commissioned William Hayes to draw her birds. Hayes eagerly accepted the job: he had no fewer than 23 children and so, not surprisingly, was always short of money. His drawings were later engraved for publication as *Birds in the Collection of Osterley Park* (1779–86) and *Rare and Curious Birds from Osterley Park* (1794).

(*Above*) Thomas Bewick (1753–1828)

The Black Ouzel

From *History of British Birds*, 1797

(*Below*) John Bewick (1760–95)

Cherryburn, Eltringham, 1781

PRIVATE COLLECTION

When I first undertook my labours in Natural History, my strongest motive was to lead the minds of youth to the study of that delightful pursuit. . . . My writings were intended chiefly for youth; and the more readily to allure their pliable, though discursive, attention to the Great Truths of Creation, I illustrated them by figures delineated with all the fidelity and animation I was able to impart to mere woodcuts without colour; and as instruction is of little avail without constant cheerfulness and occasional amusement, I interspersed the more serious studies with *Tale*-pieces of gaiety and humour; yet even in these seldom without an endeavour to illustrate some truth, or point some moral.

Bewick was born on his family's small Northumbrian farm at Cherryburn, fourteen miles west of Newcastle, in 1753. Memories of his childhood in the rolling countryside of the Tyne valley coloured the rest of his life, which was mostly spent in Newcastle. (He made one brief visit to London, and hated it.) It is not surprising therefore to find views of his birthplace (now in the care of the National Trust) creeping into the backgrounds of both the serious illustrations and the humorous tailpieces in his most famous work, the *History of British Birds*.

Mary Ward (1827–69)

Dancing Insects

From *The Microscope*

CASTLE WARD, CO. DOWN (Bangor Collection)

'Yes I have a pair of eyes,' replied Sam, 'and that's just it. If they wos a pair o' patent double million magnifyin' gas microscopes of hextra power, p'raps I might be able to see through a flight o' stairs and a deal door; but bein' only eyes, you see, my vision's limited.'

Sam Weller in *Pickwick Papers*, 1837

Around the time *Pickwick Papers* was published, the young Mary King was given her first microscope. From an early age she had collected botanical and zoological specimens, encouraged by her enlightened governess and mother. She set about producing a series of meticulous drawings of the creatures observed through her microscope, which she exhibited in her school-room at Ballylin. When she was eighteen, the English astronomer Sir James South paid a visit, and recognising Mary's talent, encouraged her parents to buy her the best instrument they could find. She kept it all her life, and with it produced a series of highly successful books on the subject, such as *Sketches with the Microscope* (1857).

In 1854 she married Captain Henry Ward, the younger brother of the 4th Viscount Bangor of Castle Ward in Co. Down, and apart from presenting him with eight children, she supported the family more or less unaided from her dowry. Her married life was to be exhausting and short. In August 1869 she was thrown from a steam carriage invented by her cousin, the pioneering astronomer William, Lord Rosse, and killed instantly. She was buried in the family vault in Birr Castle, but her microscope and the beautiful drawings she produced with it are now displayed at Castle Ward.

Anonymous *Caricature of the Other Club* CHARTWELL, KENT (Churchill Collection)

Churchill loved his home at Chartwell for many things, but especially for the view and the animals. When he made a brief visit in May 1942, he found 'the goose I called the naval aide-de-camp and the male black swan have both fallen victims to the fox. The Yellow Cat however made me sensible of his continuing friendship, although I had not been there for eight months.' When the cat later died during one of the blackest weeks of the war, his wife insisted that the news be kept from him, because she knew how much it meant to him.

It is not surprising therefore that Churchill and his allies would have taken feline form in this caricature of the Other Club. The Club had been founded in 1911 by Churchill and his friend F.E. Smith as a place where MPs from both sides of the house could meet to talk frankly with interesting people from other walks of life. 'Nothing in the rules of intercourse of the Club shall interfere with the rancour or asperity of Party politics', but openness encouraged good fellowship, and the Other Club soon became a friendly forum for Churchill

and those whose advice he respected. Churchill stands in the centre holding pipe and glass aloft. His devoted protégé Brendan Bracken is opening another bottle on the left. Fourth from the right, his scientific adviser, the teetotal Frederick Lindemann ('the Prof'), puffs at his pipe and looks on somewhat disapprovingly at the jollification. The picture is based loosely on a caricature by Hogarth. An apt choice, as Churchill enjoyed life with a gusto that the eighteenth century would have recognised and applauded.

Animals [129]

G.E. Oliver after Mayson Keown *Sheep Markings* From Joseph Walker's *Shepherd's Guide*, 1817 THE NATIONAL TRUST

Canon Hardwicke Rawnsley, one of the three founders of the National Trust, describes how the hardy Herdwick sheep of the Lake District are marked:

Before the lambs go up to the fells they are ear-marked and 'smit' or 'smitted'. These ear-marks come down from a very ancient past. They are the 'lug'-marks or 'law'-marks of the Norsemen, 'lug' and 'log' being in the Scandinavian tongue the same word for law. Each flockmaster has his own mark. Some ears are 'slit'; others are 'ritted'; others are 'tritted'; others are 'spoon'-marked; others are 'key-bitted', 'fork-bitted', 'under-bitted', 'upper-halved', 'under-halved', or 'half-sheared'. Others again are 'stoved', 'stuffed' or 'cropped', that is, have the whole of the tip of the ear cut off. It is only certain manorial hall farms that have the right to cut off the whole ear. It is considered a very dishonourable thing to tamper with the ear or lug-mark. The word 'cut-lug', as applied to a man, is a term of greatest opprobrium. The first thing that a sheep-stealer would do, of course is to tamper with the lug-marks, or to cut off the whole ear to prevent recognition.

With regard to the 'smit'-marks, these take the form of bugles, or sword marks or crosses, or simply 'smits' or 'strakes', with 'pops' or dots, and these in black or red or blue are put on different parts of the body, according to the flockmaster's traditional usage.

James Lynch (b.1965) *Bonnie, a Longhorn Cow*, 1989 WIMPOLE HALL, CAMBRIDGESHIRE (Foundation for Art)

On 17 October 1802 the Norfolk parson James Woodforde made the last entry in his diary: 'Very weak this morning, scarce able to put on my Cloaths and with great difficulty get down stairs with help . . . Dinner to day, Rost Beef etc.' In that world, where 'stout' was a term of praise rather than abuse, roast beef, and plenty of it, was seen as every Englishman's birthright. Farmers bred their cattle as fat as possible, and commissioned journeyman artists to commemorate prize animals. If such pictures are to be believed, these beasts more resembled grand pianos than the lean creatures we know today.

As we have become more particular about what we eat, we seem to have lost our taste for variety. Many of the less productive breeds of cattle have been allowed to die out, to be replaced by the ubiquitous Limousin and Charollais. However, there are those who believe that these historic breeds deserve protection just as much as historic buildings. The Trust has combined both campaigns by making Sir John Soane's 200-year-old Home Farm at Wimpole a centre for rare farm animals. And James Lynch has revived the tradition of animal painting with portraits of beasts like Bonnie, who was reared at Wimpole and was Breed Champion at the 1989 Royal Show.

In the background is the Gothic Tower designed by Sanderson Miller and built on Johnson's Hill in 1774.

Animals [131]

J.M.W. Turner (1775–1851) *Aberdulais Mill*, *c.*1795 EXECUTORS OF THE LATE MR NICHOLAS PHILLIPS

MILLS AND MINES

Much alter'd now the scene appears;
And trade its busy form uprears;
Where silence reigned, now tumult rings;
So change is mark'd on human things.

William 'Weston' Young
on Aberdulais Falls,
W. Glamorgan, 1835

Atkinson Grimshaw (1836–93) *Autumn Glory: The Old Mill*, 1869 LEEDS CITY ART GALLERIES

The water-mill in the park at Dunham Massey dates back to 1616, when it was built by 'old Sir George' Booth – 'free, grave, godley, brave Booth, flower of Cheshire', as one of his Puritan admirers called him. The mill survived the political convulsions of the Civil War, which took his grandson, 'young Sir George', to the Tower, and the changes in taste which transformed both the house and park. Two hundred and fifty years later Grimshaw painted it in a state of benign neglect, almost hidden by brambles.

The Leeds painter Atkinson Grimshaw is best known today for his moonlit streetscenes, in which it always seems to be autumn and the pavements always seem to be wet. He began his career with landscapes in an altogether brighter, Pre-Raphaelite key. *Autumn Glory* marks a transition between the two styles. The building and the brambles that surround it are painted with a painstaking accuracy of which Ruskin and the Pre-Raphaelites would have been proud, but the moody autumnal atmosphere is more characteristic of his later work. It is doubtful, however, whether Grimshaw himself ever made the journey across the Pennines to see the Dunham mill for himself, as he painted both building and vegetation from photographs, which may explain why the mill appears back-to-front.

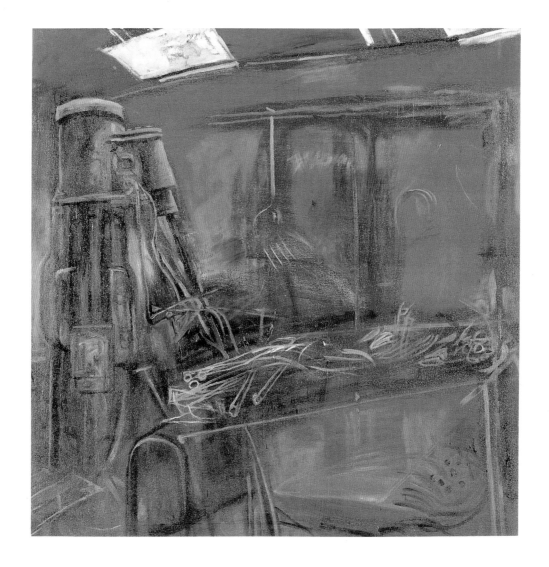

Jack Crabtree (b.1938) *Patterson's Spade Mill* FOUNDATION FOR ART

The spade has played a central part in the life of the Irish, whether to dig peat or potatoes, canals or railway cuttings; and for much of this century Patterson's Spade Mill in Templepatrick, Co. Antrim, provided these essential tools. John Patterson, great-grandson of the mill's founder, describes how the skills of spade-making are passed on:

There are no gauges and measurements for making a spade, a piece of steel four inches by two inches by three-quarters of an inch can be made into any type of spade.

At the last count there were 171 different types of spade throughout all of Ireland, and for a man to know these different types of spade, with no template, just shows the skill involved, and the task always fell to my father, because he was the oldest brother.

It was a hierarchical line. My grandfather learned from his father, my father learned from my grandfather, and just as the older men passed away, so the younger men came up the line.

Mills and Mines [135]

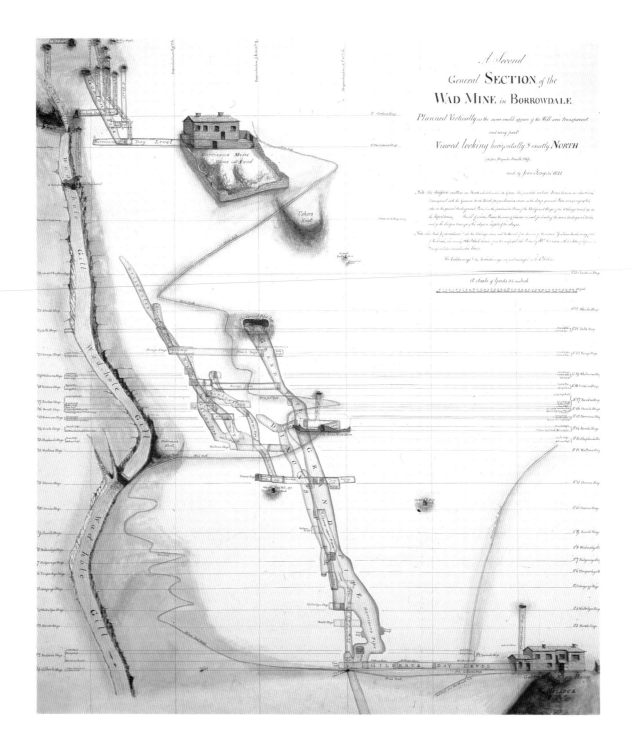

John Farey Senior

A Second General Section of the Wad Mine in Borrowdale, 1821

THE NATIONAL TRUST

In the eighteenth century artists on sketching tours of the Lakes used pencils made from graphite, or 'wad', mined almost exclusively in nearby Borrowdale. The graphite had other, more dubious applications, as the Rev. Thomas Robinson explained in his *Essay towards a Natural History of Westmorland and Cumberland*:

It's a present *Remedy* for the *Cholick*; it easeth the Pain of *Gravel*, *Stone*, and *Strangury*; and for these and the like Uses, it's much bought up by *Apothecaries* and *Physicians*, who understand more of its *medicinal* Uses than I am able to give Account of.

The manner of the County Peoples using it, is thus; First, they beat it small into *Meal*, and then take as much of it in white Wine, or Ale, as will lie upon a *Sixpence*, or more, if the Distemper require it.

It operates by *Urine*, *Sweat*, and *Vomiting*. This Account I had from those who had frequently used it in these Distempers with good Success.

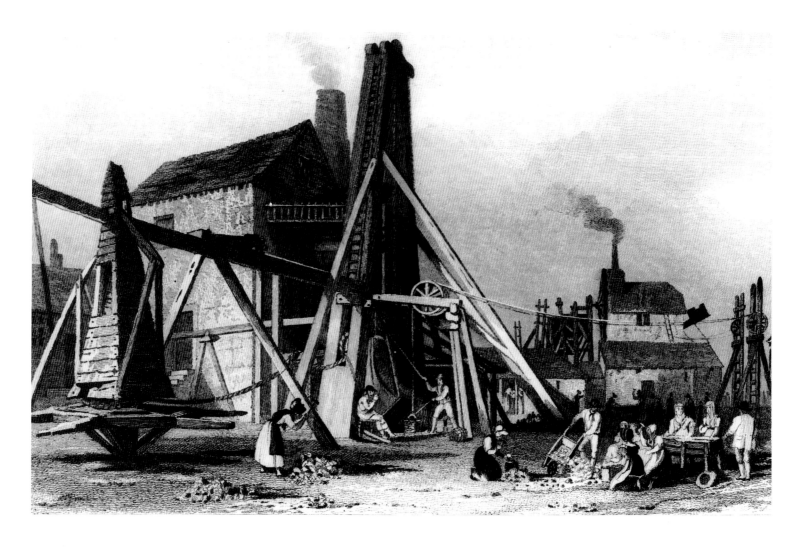

English, *c.*1830 *The Mine-head at Dolcoath* ROYAL INSTITUTION OF CORNWALL, TRURO

There is another side to the Cornwall of little fishing ports and rocky coves loved by summer holiday-makers. The county, and particularly the area around Camborne and Redruth, has a long history of copper and tin mining, which covered the landscape with spoil heaps and engine-houses. William Beckford visited the mines near Gwennap in 1787, and was appalled at what he found there:

They are situated in a bleak desert, rendered still more doleful by the unhealthy appearance of its inhabitants. At every step one stumbles upon ladders that lead into utter darkness, or funnels that exhale warm copperous vapours. All around these openings the ore is piled up in heaps waiting for purchasers. I saw it drawn reeking out of the mine by the help of a machine called a whim, put in motion by mules, which in their turn are stimulated by impish children hanging over the poor brutes, and flogging them round without respite. This dismal scene of *whims*, suffering mules, and hillocks of cinders, extends for miles. Huge iron engines creaking and groaning, invented by Watt, and tall chimneys smoking and flaming, that seem to belong to old Nicholas's abode, diversify the prospect.

Mills and Mines [137]

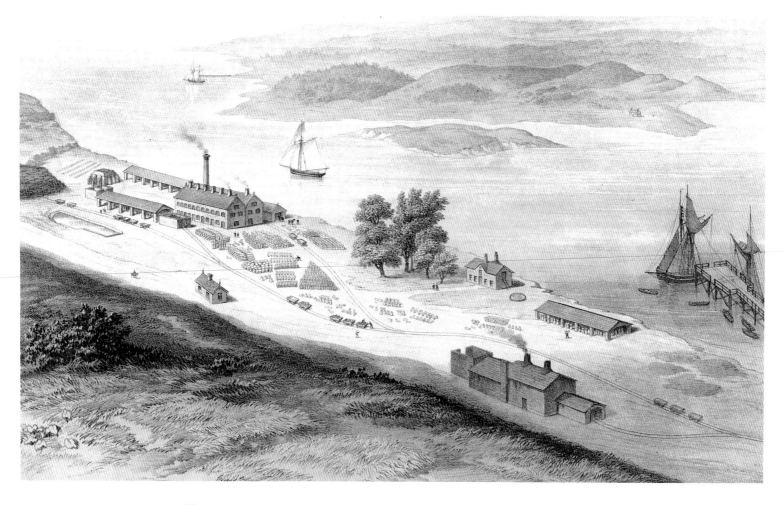

Anonymous *The Branksea Clay & Pottery Company works, Dorset*, 1850s THE NATIONAL TRUST

Brownsea Island today is a haven for wildlife in the bustle of Poole harbour, but it has a long history of industrial exploitation. In the late seventeenth century Celia Fiennes saw copperas (or ferrous sulphate) being mined on Brownsea for use in the building industry. One hundred and fifty years later came the following brief and sad episode.

In 1852 Brownsea Island was put up for sale. Among those who came to look round were an ex-Indian Army officer, Col. William Waugh, and his wife, Mary. As they strolled along the beach, she noticed a white mud sticking to the end of her walking stick which she thought might be china clay. A geologist confirmed her suspicions, and the excited couple, seeing a chance to make their fortune, bought Brownsea for £13,000. Waugh erected a huge pottery works at the north-west end of the island, together with a village, which he named Maryland after his wife, to house the factory workers. Alas, the Brownsea clay proved unsuitable for making fine china, but Waugh continued to pour money into the project with increasing desperation.

Disaster finally struck when a group of local businessmen arrived to ask Col. Waugh to stand for Parliament. Mary Waugh was rather deaf and, thinking that they had come about unpaid bills, pleaded for more time to settle. When the puzzled tradesmen compared notes, the Waughs' ambitious enterprise collapsed, and they were forced to flee to Spain. Today there is little sign left of all their efforts, bar the overgrown foundations of the demolished Maryland and shards of the drainage pipes which were all that the Waughs' factory was able to produce.

NOTES

In addition to the relevant National Trust guidebooks, the following sources have been quoted from or proved invaluable in compiling this book:

CHAPTER ONE

Page 9 Thomson's 'Autumn' is dedicated to Arthur Onslow, Speaker of the House of Commons (1728–61) and father of the 1st Earl of Onslow of Clandon Park, Surrey (also the property of the National Trust): see J. Logie Robertson, ed., *The Complete Poetical Works of James Thomson*, Oxford University Press, 1908. John Barrell, *The Dark Side of the Landscape*, Cambridge University Press, 1980, pp.24–31. *George Stubbs 1724–1806*, Tate Gallery, London, 1984, pp.166–9.

10 Merlin Waterson, *The Servants' Hall*, Routledge & Kegan Paul, London, 1980, pp.30–3.

11 J. Geraint Jenkins, *Life & Tradition in Rural Wales*, Dent, London, 1976, p.175.

14 Felix Farley's Bristol journal, 26 February 1825, quoted in Francis Greenacre, *The Bristol School of Artists: Francis Danby and Painting in Bristol 1810–1840*, City Art Gallery, Bristol, 1973, p.121; see also pp.133–6.

15 H. Allingham and D. Radford, ed., *William Allingham: A Diary*, Macmillan, London, 1907, p.308.

18–19 Christopher St John, ed., *Ellen Terry and Bernard Shaw: A Correspondence*, The Fountain Press, New York, and Constable, London, 1931, pp.322–3.

20–1 Laurence Whistler, *The Laughter and the Urn: The Life of Rex Whistler*, Weidenfeld & Nicolson, London, 1985, p.210.

23 'Ksynia Marko's Diary', *National Trust Magazine*, autumn 1992, p.39.

CHAPTER TWO

25 Roger Lonsdale, ed., *The New Oxford Book of Eighteenth-Century Verse*, Oxford University Press, 1984, p.169.

26–7 Elizabeth Einberg and Judy Egerton, *The Age of Hogarth: British Painters born 1675–1709*, Tate Gallery, London, 1988, pp.156–9. Christopher Morris, ed., *The Illustrated Journeys of Celia Fiennes c.1682–c.1712*, Macdonald, London, 1982, p.63. John Macky, *A Journey through England in Familiar Letters from a Gentleman Here to His Friend Abroad*, 1714, i, p.76. Clive Aslet, *Country Life*, 26 August 1993.

28 Richard and Samuel Redgrave, *A Century of British Painters*, Phaidon, London, 1947, p.45. David H. Solkin, *Richard Wilson: The Landscape of Reaction*, Tate Gallery, London, 1982, no.135, pp.239–41.

29 *Landscape in Britain c.1750–1850*, Tate Gallery, London, 1973, no.134, p.68.

30 E. Rhodes, *Peak Scenery; or, the Derbyshire Tourist*, Longman, London, 1824, p.8.

31 Thomas Rose, *Westmorland, Cumberland, Durham and Northumberland Illustrated*, Fisher, Fisher & Jackson, London, 1835, iii, p.215.

32 Leslie Parris and Ian Fleming-Williams, *Constable*, Tate Gallery, London, 1991, no.57, pp.131–2. Merlin Waterson, 'Constable's Views under Threat', *Country Life*, 18 June 1992.

33 Eric Adams, *Francis Danby: Varieties of Poetic Landscape*, Yale University Press, London, 1973, pp.29, 34–6, no.9, p.171. Francis Greenacre,

Francis Danby 1793–1861, Tate Gallery, London, 1988, pp.17–18, no.11, p.84.

34–5 Julian Treuherz, 'The Graphic', *Hard Times*, Lund Humphries, London, 1987, pp.53–64.

36 Ronald Alley, *Graham Sutherland*, Tate Gallery, London, 1982, nos 54–5, pp.78–9. Myfanwy Evans, ed., 'An English Stone Landmark', *The Painter's Object*, 1937.

37 *Paul Nash*, Tate Gallery, London, 1975, p.13, no.120, pp.77–8.

38–9 Edward Grey, *Twenty-Five Years, 1892–1916*, 1925, ii, ch.18. G.M. Trevelyan, *Grey of Falloden*, Longman, Green & Co., London, 1937, pp.147–8.

CHAPTER THREE

42–3 W.G. Strickland, *A Dictionary of Irish Artists*, Dublin, 1913, i, pp.304–5. Anne Cruikshank and the Knight of Glin, *The Painters of Ireland c.1660–1920*, Barrie & Jenkins, London, 1979, p.62.

44 Kathryn Cave, ed., *The Diary of Joseph Farington, July 1809–December 1810*, x, Yale University Press, London, 1982, pp.3742–3.

45 William Holman Hunt, *Pre-Raphaelitism and the Pre-Raphaelite Brotherhood*, Macmillan, London, 1905, ii, pp.214–15. *The Pre-Raphaelites*, Tate Gallery, London, 1984, no.232, pp.292–3. Robert Bernard Martin, *Tennyson: The Unquiet Heart*, Clarendon Press, Oxford, 1983, p.434.

46 Leo Walmsley, *Foreigners*, Jonathan Cape, London, 1935, pp.93, 94. Leo Walmsley, *So Many Loves*, Collins, London, 1944.

47 *Joseph Southall 1861–1944: Artist-Craftsman*, Birmingham Museums and Art Gallery, 1980, no.F9, pp.68–9.

48–9 Maire-Anne de Bovet, *Trois Mois en Irlande*, Hachette, Paris, 1891; translated as *Three Months' Tour in Ireland*, Chapman & Hall, London, 1891, pp.295–6.

51 Barbara Leaming, *Polanski: A Biography*, Simon and Schuster, New York, 1981, pp.66–73.

CHAPTER FOUR

53 John Ruskin, *The Poetry of Architecture*, George Allen, London, 1893, pp.48–9.

54 *Victoria County History, Berkshire*, London, 1924, iv, p.487. J.W. Mackail, *Life of William Morris*, Longman, Green & Co., London, 1899, i, p.233; ii, p.223.

55 James Gibson, ed., *The Complete Poems of Thomas Hardy*, Macmillan, London, 1976, p.3.

56 Nigel Temple, *John Nash & the Village Picturesque*, Alan Sutton, Gloucester, 1979, pp.112–15. John Summerson, *The Life and Work of John Nash Architect*, Allen & Unwin, London, 1980, pp.51–2. Michael Mansbridge, *John Nash: A Complete Catalogue*, Phaidon, Oxford, 1991, pp.74–5.

57 Nigel Temple, op. cit., *passim*. John Summerson, op. cit, pp.54–5. Michael Mansbridge, op. cit., pp.170–2.

58 Matilda Talbot, *My Life and Lacock Abbey*, Allen & Unwin, London, 1956, p.181.

59 M.J. Daunton, *Royal Mail: The Post Office since 1840*, Athlone Press, London, 1985.

60 Richard and Samuel Redgrave, op. cit., p.200. C.M. Kauffman, *John Varley 1778–1842*, Batsford, London, 1984, no.4, pp.95–6.

62–3 David Garnett, ed., *Carrington: Letters and Extracts from her Diaries*, Jonathan Cape, London, 1970, pp.189–90. Noel Carrington, *Carrington: Paintings, Drawings and Decorations*, Oxford Polytechnic Press, 1978, p.57.

64 Anne Olivier Bell, ed., *The Diary of Virginia Woolf: Volume I 1915–1919*, Hogarth Press, London, 1977, pp.287–8.

CHAPTER FIVE

67 Quoted from John D. Mortimer, *An Anthology of the Home Counties*, Methuen, London, 1947, p.171.

68–9 Francis Bamford and the Duke of Wellington, ed., *The Journal of Mrs Arbuthnot 1820–1832*, Macmillan, London, 1950, i, pp.118–19. William John Bankes, ed., *Narrative of the Life and Adventures of Giovanni Finati*, John Murray, London, 1830, ii, pp.315–16.

70 Stuart Piggott, *William Stukeley: An Eighteenth-Century Antiquary*, Thames and Hudson, London, 1985, pp.46, 94, 50.

71 Graham Reynolds, *Catalogue of the Constable Collection: Victoria & Albert Museum*, HMSO, London, 1973, no.395, p.233. Leslie Parris and Ian Fleming-Williams, *Constable*, Tate Gallery, London, 1991, no.345, pp.490–1.

72 Thomas Pennant, *A Tour in Scotland and Voyage to the Hebrides; 1772*, Chester, 1776, pp.38–9.

73 Jane Vickers, *Pre-Raphaelites: Painters and Patrons in the North East*, Laing Art Gallery, Newcastle, 1989, p.104.

74 C. Bruyn Andrews, ed., *The Torrington Diaries*, Eyre & Spottiswoode, London, 1934, i, p.351.

75 Andrew Wilton, *J.M.W. Turner: His Art and Life*, Poplar Books, Secaucus, New Jersey, 1979, no.238, p.326.

76 Martin Butlin and Evelyn Joll, *The Paintings of J.M.W. Turner*, Yale University Press, London, rev. ed., 1984, no.11, pp.8–9.

77 C. Bruyn Andrews, ed., *The Torrington Diaries*, Eyre & Spottiswoode, London, 1935, ii, p.354.

CHAPTER SIX

80 Frederick W. Dupee, ed., *Henry James. Autobiography: A Small Boy and Others*, W.H. Allen, London, 1956, p.13. Leon Edel, *Henry James: The Untried Years 1843–1870*, Rupert Hart-Davis, London, 1953, p.93. Henry James, *English Houses*, quoted from Richard Gill, *Happy Rural Seat*, Yale University Press, New Haven, 1972, p.19. F.O. Matthiessen and Kenneth B. Murdock, *The Notebooks of Henry James*, New York, 1955, p.23.

81 Quoted from Miles Jebb, ed., *East Anglia*, Barrie & Jenkins, London, 1990, p.133.

86 Emily J. Climenson, ed., *Passages from the Diaries of Mrs Philip Lybbe Powys*, Longman, London, 1899, p.285.

87 Daphne du Maurier, *Rebecca*, Penguin, London, 1962, p.376.

88–9 H.G. Wells, *Tono-Bungay*, Collins, London, 1923, p.12. H.G. Wells, *Experiment in Autobiography*, Gollancz, London, 1934, i, pp.52–3, 132–8.

90 *Standen Memories* [unpublished MS], pp.5, 8.

91 Clayre Percy and Jane Ridley, ed., *The Letters of Edwin Lutyens to his wife Lady Emily*, Hamish Hamilton, London, 1988, p.199.

CHAPTER SEVEN

94–5 Richard Carew Pole, 'Then and Now: Condy's Coloured Views of Antony', *Apollo*, cxxxvii, April 1993, pp.259–62.

96 *The Pre-Raphaelites*, Tate Gallery, London, 1984, no.122, pp.199–200. Oliver Millar, *The Victorian Pictures in the Collection of Her Majesty the Queen*, Cambridge University Press, 1992, i, no.493, pp.185–6; ii, pl.416.

97 Christopher Gilbert, *The Life and Work of Thomas Chippendale*, Studio Vista, London, 1978, i, p.175.

99 Emily J. Climenson, ed., *Passages from the Diaries of Mrs Philip Lybbe Powys*, Longman, London, 1899, pp.203–4. Trevor Lummis and Jan Marsh, *The Woman's Domain*, Viking, London, 1990, pp.91–118.

101 Judy Taylor, *Beatrix Potter: Artist, Storyteller and Countrywoman*, Warne, London, 1986, pp.112–14. Judy Taylor, Joyce Irene Whalley, Anne Stevenson Hobbs, Elizabeth M. Battrick, *Beatrix Potter 1866–1943: The Artist and her World*, Warne, London, 1987, pp.136–9.

102 Margherita Howard de Walden, *Pages from my Life*, Sidgwick & Jackson, London, 1965, pp.194–5.

103 *Daily Sketch*, 31 December 1937; *Evening Standard*, 22 December 1937, quoted from Gavin Stamp, 'Goldfinger – The Early Years', *Ernö Goldfinger*, Architectural Association, London, 1983, pp.9–14.

CHAPTER EIGHT

105 Quoted from Roger Lonsdale, ed., *The New Oxford Book of Eighteenth-Century Verse*, Oxford University Press, 1984, p.495.

106 Romney Sedgwick, ed., *Memoirs of the Reign of King George II by John, Lord Hervey*, London, 1931, i, p.162. Gervase Jackson-Stops, *An English Arcadia 1600–1990*, National Trust, London, 1992, no.29, pp.54–6.

107 Philip Yorke, 'A Journal of What I Observed Most Remarkable in a Tour into the North', Bedfordshire Historical Record Society, 1968, quoted from John Dixon Hunt and Peter Willis, ed., *The Genius of the Place*, MIT Press, Cambridge, Mass., 1988, pp.237–8.

109 Jackson-Stops, op. cit., no.46, pp.74–5. Dixon Hunt and Willis, op. cit., p.273.

110 *Diaries and Letters of Madame D'Arblay, vol.v. 1789–1793*, Henry Colburn, London, 1843, pp.55–6.

111 Jackson-Stops, op. cit., no. 41, pp.68–70. Anne Fremantle, ed., *The Wynne Diaries*, Oxford University Press, London, 1940, iii, p.194.

114 The Rev. John Evans, *Tour through North Wales*, quoted from Alice Thomas Ellis, *Wales: An Anthology*, Collins, London, 1989, p.82. Catherine Sinclair, *Hill and Valley, or Wales and the Welsh*, William Whyte, Edinburgh, 1839, pp.94–8.

115 William Plomer, ed., *Kilvert's Diary*, Jonathan Cape, London, 1939, ii, pp.406–7.

117 Edward Kemp, *Gardeners' Chronicle*, 1856.

118 Quoted from Charles Paget Wade's largely unpublished memoirs, *Days Far Away*. Jackson-Stops, op. cit., no.116, pp.146–8.

119 Jackson-Stops, op. cit., no.109, pp.140–1.

120 The Marchioness of Londonderry, *Retrospect*, Frederick Muller, London, 1938, pp.214, 210.

121 James Lees-Milne, *Ancestral Voices*, Faber, London, 1984, p.205.

CHAPTER NINE

123 Robert Latham and William Matthews, ed., *Samuel Pepys's Diary*, Bell, London, 1971, iv, p.26.

124–5 *George Stubbs 1724–1806*, Tate Gallery, London, 1984, no.138, pp.181–2.

127 Thomas Bewick, *History of British Birds*, 1826, i, pp.iii–vi. Iain Bain, *The Watercolours and Drawings of Thomas Bewick and his Workshop Apprentices*, St Paul's Bibliographies, Winchester, 1989, 2 vols.

128 Mary Beckett, 'Under the Microscope', *National Trust Magazine*, spring 1993, pp.38–9. *The Social History of the Microscope*, Whipple Museum of the History of Science, Cambridge, n.d.

130 Hardwicke Rawnsley, *By Fell and Dale*, 1911.

131 John Beresford, ed., *The Diary of a Country Parson 1758–1802 by James Woodforde*, Oxford University Press, 1935, pp.618–19.

CHAPTER TEN

133 William Young, *Guide to the Scenery etc of Glyn-Neath*, Bristol, 1835, p.19. Richard Keen, 'Horrid and Curious: Art and Early Industrialization in Wales', *Apollo*, cxxxvii, April 1993, pp.240–3.

134 *Atkinson Grimshaw 1836–1893*, Leeds City Art Gallery, 1979, no.14, p.26.

136 The Rev. Thomas Robinson, *An Essay towards a Natural History of Westmorland and Cumberland*, 1709.

137 Guy Chapman, ed., *The Travel-Diaries of William Beckford of Fonthill*, Constable, London, 1928, ii, p.7.

ACKNOWLEDGEMENTS

This book could not have been written without the past efforts and present support of my colleagues in the National Trust, in particular Marie Miller and Francesca Scoones, who has an unrivalled knowledge of early representations of the Trust's properties. The staff of the London Library have been equally helpful. Many other people have come to my aid, especially: Iain Bain, Sally Brown, George Clarke, Austin Frazer, J. Paul Getty, Christopher Gibbs, Francis Greenacre, Cathy Henderson, Christopher Newall, Penny Ruddock, Francis Russell and Stephen Wildman. I would also like to thank the following for permission to reproduce copyright material:

J.M. Dent & Sons Ltd for the extract from J. Geraint Jenkins's *Life & Tradition in Rural Wales*; A.P. Watt for the extract from H.G. Wells's *Tono-Bungay*; the Society of Authors on behalf of the Bernard Shaw Estate for Shaw's letter of 3 April 1902 to Ellen Terry; Yale University Press for the extract from Joseph Farington's diary; Jonathan Cape for the extract from Leo Walmsley's *Foreigners*; Austin Frazer for his memories of Orfordness; Allen & Unwin for the extract from Matilda Talbot's *My Life and Lacock Abbey*; Mrs Frances Partridge for the extracts from the letters of Dora Carrington; Prof. Quentin Bell for the extract from the diary of Virginia Woolf; Macmillan London for the extract from the journal of Harriet Arbuthnot; Viking Penguin for the extract from Daphne du Maurier's *Rebecca*; Frederick Warne & Co. for the extract from Beatrix Potter's 1906 letter to Millie Warne; Lord Howard de Walden for the extract from Margherita, Lady Howard de Walden's *Pages from my Life*; James Lees-Milne for the extract from his diaries.

PHOTOGRAPHS
City of Aberdeen Art Gallery & Museums Collections p.37; Norman Ackroyd p.24; Assembly Rooms, Bath pp.12–13; Robert Bates/Foundation for Art, National Trust Photographic Library p.65; Birmingham Museum and Art Gallery p.50; Bodleian Library, Oxford (Gough Map Collection 231 f.5 recto) p.70; Bristol City Art Gallery/John Webb p.33; British Library, Dept of Manu-scripts p.74; British Museum, Dept of Prints and Drawings p.92; Buckinghamshire County Museum, Aylesbury/NTPL p.111; Christie's pp.34–5; Courtauld Institute of Art, Conway Library p.115; Jack Crabtree/FfA p.135; Prudence Cuming Associates Ltd p.46; Trustees of the Thomas Hardy Memorial Collection, Dorset County Museum, Dorchester p.55; by gracious permission of Her Majesty Queen Elizabeth the Queen Mother p.96; Richard Foster/FfA, NTPL p.23; Cherryl Fountain/FfA, NTPL p.120; Hereford City Museums and Art Galleries front cover, p.47; Icon Design Consultants p.58; Carl Laubin/FfA, NTPL p.78; Leeds City Art Galleries p.134; Leeds City Art Galleries/Courtauld Institute of Art p.29; James Lynch/FfA, NTPL p.131; National Museum of Wales, Cardiff p.28; National Trust pp.18, 30, 31, 44, 48–9, 52, 54, 57, 59, 61, 66, 72, 76, 80, 81, 82, 87, 95, 98, 114, 121, 126, 127 (above), 136; NT/Richard Pink p.68; NT/Sue Sieger p.138; NT/Robert Thrift p.130; National Trust Photographic Library pp.7, 10, 20, 21, 32, 64, 73, 77, 84, 85, 86, 88, 91, 110, 116, 122, 124–5, 128; NTPL/Michael Boyes p.15; NTPL/Roy Fox p.90; NTPL/Ray Hallett p.40; NTPL/John Hammond pp.2, 56, 103, 106; NTPL/Angelo Hornak pp.8, 107, 109, 118, 119; NTPL/Gordon H. Roberton p.22; NTPL/Jeremy Whitaker p.97; NTPL/Mike Williams pp.83 (by permission of Lord Scarsdale), 108; NTPL/Derrick E. Witty pp.14, 16, 19, 69, 99, 104, 129, back cover; Plymouth City Museum and Art Galleries p.94; Harry Ransom Humanities Research Center, University of Texas at Austin p.62; Leonard Rosoman/FfA, NTPL p.16; Royal Institution of Cornwall, Truro p.137; St Andrews University Library p.100; William Salt Library, Stafford p.117; Shell Archive, National Motor Museum, Beaulieu p.36; Len Tabner/FfA, NTPL p.51; Tate Gallery, London pp.26–7, 63, 112–13; Ulster Museum, Belfast pp.42–3; Victoria & Albert Museum, London pp.60, 71; Glynn Vivian Art Gallery, Swansea City Leisure Services Dept p.11; Frederick Warne & Co. p.101; John Webb p.45; Jeremy Whitaker p.102; Derwent Wise/FfA, NTPL pp.38–9; Leslie Worth/FfA, NTPL p.89; York City Art Gallery p.75.

INDEX